Eerie

FLORIDA

Eerie
FLORIDA

CHILLING TALES FROM
THE PANHANDLE TO THE KEYS

Mark Muncy & Kari Schultz

THE
History
PRESS

Published by The History Press
Charleston, SC
www.historypress.net

Cover: Florida state seal as enhanced by Kari Schultz, 2017.
Opposite: Retro postcard of Florida. *Courtesy of the St. Petersburg Museum of History*.

All images are by the author unless otherwise noted.

First published 2017

Manufactured in the United States

ISBN 9781625859853

Library of Congress Control Number: 2017940953

Notice: The information in this book is true and complete to the best of our knowledge. It is offered without guarantee on the part of the author or The History Press. The author and The History Press disclaim all liability in connection with the use of this book.

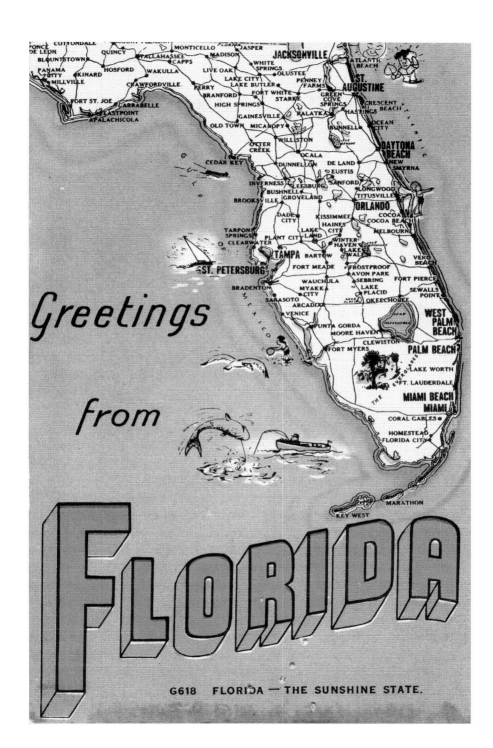

Greetings

from

FLORIDA

G618 FLORIDA — THE SUNSHINE STATE.

CONTENTS

CONTENTS

ACKNOWLEDGEMENTS

*K*ari and I know that no book ever appears from just the author and illustrator. This book is no exception. We'd like to thank primarily Marta Jones and the wonderful folks at the St. Petersburg Museum of History for all their help and support in finding so many of the amazing pictures and much of the history you will find in this book. We have to thank Deborah Fretham and Doug Stenroos (aka The Sheriff) for inspiring us with so many ghostly tales and weaving them with history between St. Petersburg and St. Augustine, respectively. We want to seriously thank Nancy Alloy and Amanda Leaders at Books at Park Place for covering so many shifts while I wrote this and for years of support. We'd like to thank our friends, the staff of Trader Joe's in St. Petersburg, without whom we wouldn't be able to afford to feed ourselves, let alone travel the state. The crew has so many fun people to work with that the place truly is more like a family than just a job.

A very special thank-you to all our editors who helped get our rough first draft into fine form, including Mark's previous coauthor Elizabeth Abbott, the incomparable Laura Kelleher, the charming Prudence Monroe, the multitalented Susan Irving, the dearest Kim Dunn, the wonderful hostess of Haunted Heritage Hikes in St. Petersburg Stephanie Moffett, the amazing Dani Seequin, the divine twosome of Kaitlyn and Jennifer Brass, quick-witted Tammy Ramsey, the astonishing Kim Kelly, the astounding Ivy Redfield, the spectacular Emory Morris and the incredible Valerie McBurney. A special big thank-you to Brandy Stark of SPIRITS of St.

Petersburg for some fodder for additional material and lending a late assist with the edits as well.

I'd love to thank my Hellview Cemetery family, who put up with our madness for over twenty years. Dale Aden Jr., Amanda Warrant, Nick Tinnerello, Madison Meeks, Sally Gage, Leisa Clark, Pat Simmons, Zachary Ryan and so many others, we couldn't have done it without you. Several of them also assisted with early reads and suggested edits. We, of course, have to thank Jimmy Haugh, who dug that fateful first grave and found the bones that started this whole journey.

A heartfelt thank-you to all the wonderful folks at The History Press! Amanda Irle, you are incredible and made of pure win!

Finally, we need to thank our families. We shall soon be joining these two groups together as one by marriage, but we are already one large family anyway. Beth and Callie have welcomed Kari with open arms. A big thank-you to Dan Blastorah for all the wonderful crab meat, BBQ and for already treating us like family. Mark even got permission from Kathy Schultz and Paul Schultz before asking Kari to marry him, which means he must be OK in their book.

INTRODUCTION

*F*lorida is known for so many things. It is home to world-class beaches that surround the state on three sides. It is where we reach for the stars at the Florida Space Coast. It is home to the amazing tourist attraction capital of the world in Orlando. So much fun can be found in this amazing state all the way down to the wonderfully wacky Florida Keys. The state draws tourists by the millions, and every year, more and more people move to the state in record numbers. There is one more thing the state is known for, and that is crazy stories about crazy people and places.

In 1984, I was one of those people whose families decided it was time to move to Florida and leave the cold winters of the Midwest behind. My father was with the Greyhound Bus corporation and had come down to Tampa Bay in 1980 when the Skyway Bridge disaster occurred. Despite the tragic reason for his visit, he became enchanted with the area, mostly due to "one amazing sunset." When he retired for health reasons a few years later, he knew St. Petersburg was to be our home.

As with any family, we visited lots of places all over the state. I was just starting high school at the time and began my first solo journeys into this wonderful state when I was able. Being attracted to the creative arts more than sports, much to my father's original disappointment, I started working in local theaters, Renaissance festivals and even the occasional TV or voice-over gig. When my favorite time of year finally arrived, I would seek out the area's haunted houses, eventually even working for Halloween Horror Nights at Universal Studios as a scareactor.

By this time, I was a father of two, and I decided that family time was more important than scaring tourists, but my love of Halloween was very powerful. I decided to decorate my house and build a haunted house display. When digging a grave in my front yard in St. Petersburg, we discovered a mess of seashells and bones just a foot or so into the earth. When my comrade in arms, Jimmy, thought some of the remains might be human, we called the authorities. They told us it was probably a midden and they'd send somebody from the Junior College to check it out.

I had been to Serpent Mound in Ohio and had lived in South Charleston, West Virginia, where a mound dominated the center of its downtown area. Having watched so many horror movies hosted by legendary horror host Dr. Paul Bearer, my mind began to wonder what ancient evil I had unearthed. The archaeologist who came out was polite and told us this was just a shell midden and we could dig away, but to be on the lookout for any pottery or tools.

As he left, he said, "I'm just glad it wasn't one of the lost cemeteries."

My mind raced with the prospect of "lost cemeteries." I had lived in the bay area for a number of years and had never heard about missing cemeteries. I started researching them that very night. This was in the early days of the Internet, and I even had to go to my favorite place in the world: the library. It wasn't long before I read about a few of the missing cemeteries, and one name stood out: Hillview Cemetery. The *Tales from the Crypt* fan in me knew my little haunted yard was going to become Hellview Cemetery and the lost graveyards of Tampa Bay would rise up every Halloween.

For nearly twenty years, my yard would transform into a crazy haunted house with an army of volunteers. We began to take donations as the crowds started growing. Every dime went to charities like Child's Play or the St. Jude's Foundation or local charities like the Kind Mouse, which feeds transitional families in the Tampa Bay area. It was a huge success.

I had become obsessed with local history and legends and began to incorporate more and more of these into the haunted house. I figured the ties to the local lore may not be noticed by some, but others would appreciate it. Rather than just having some guy in a werewolf mask jump out at you, why not the Florida Skunk Ape? I started taking notes and jotting down ideas whenever I would stumble upon a great story.

As we entered our nineteenth year, we had gotten too big for our little neighborhood, and the City of St. Petersburg finally told us we

had to quit. A neighbor had become terrified of our haunt and felt the devil would come to take him if we didn't stop. We looked for a secondary location, but it was too late in the year to truly build what our audience demanded.

I decided I could keep up the legends by finally writing a book with all these stories I had collected over the years. The fiction lover in me still wanted to spice these tales up and make them fit in with what our haunted house had become. So with the assistance of coauthor Elizabeth Abbott, we created *31 Tales from Hellview Cemetery*. Purple Cart Publishing helped us get it into print. With no Hellview again the following year, the book was transformed into *Tales of Terror from Tampa Bay*, where we removed the completely fabricated Hellview legends and just included stories inspired by local ghost stories, but these were still simply fictionalized stories.

I looked at my collection of over twenty years of notes, files, pictures, .mp3 files and even videos. It was clear it was time to write the real stories down. There were already many books on the ghost stories and even more on the dark history of our state. Most of these told the tales of the ghosts of famous people in famous locations. These tales I had seen and heard dozens of times by taking the many ghost tours in the many beach towns in the state. Very few talked about the odd or crazier tales in some of the spots that weren't tourist hot spots. It amazed me that I had some stories that only I seemed to have discovered. Many had been reported on so very little, even among local paranormal experts.

I realized quickly that my stories would still need some sort of direction. Deborah Fretham, a local ghost historian in Tampa Bay and an author of several ghostly books about the area, suggested I talk to The History Press, her publisher. There was my hook; Florida history was so integral to many of these stories. With that, *Eerie Florida* was born.

My fiancée, the amazing Kari Schultz, and I began a whirlwind tour of the sites we intended to cover. Driving nearly three thousand miles and never leaving the Sunshine State, we managed to obtain a boatload of unusual pictures and even discovered a few more stories on the way. Knowing I'd probably never get Pinky or the Skunk Ape to pose for a picture, and since a few of these places we went to were nothing more than foundations now, I knew we would need some incredible archival photos and maybe some illustrations. It's a great thing Kari is an amazingly talented artist and I had a wonderful friend named Marta Jones who is an archivist at the St. Petersburg Museum of History.

Now just a friendly word of advice before you begin your journey into *Eerie Florida*. What you read may shock you. It may thrill you. It may even horrify you. So if you feel you should not want to subject yourself to such a strain on your nerves…well, don't say I didn't warn you.

—Mark Muncy
March 3, 2017—Florida's 172nd birthday as a state

WICCADEMUS

Fernandina Beach

On beautiful Amelia Island, there is a wonderful Atlantic Recreation Center full of information about the wetlands it borders and the undeveloped Egans Creek Greenway trails that snake throughout the nearby woods and wetlands. There are warning signs about some of the local wildlife, including alligators and even bobcats. It opened in 2000 for conservation and passive recreational use. There are benches and grass and dirt pathways offering some of the most breathtaking views in all of northeastern Florida. The park itself does have some thorny vines, a little poison ivy and, of course, the most notorious residents of all of Florida: the mosquitoes. It is still a great place to bike or walk to enjoy several different ecosystems in just a few miles of exploration.

One area is a giant saltmarsh. It is a beautiful place to watch for herons, egrets, ospreys, and other wading birds. There is a platform designed just for wildlife watching that rises over the saltmarsh area near the Atlantic Avenue entrance to the Greenway. From there you can cross the creek itself via a couple of wooden bridges into other areas of the park. Closer to the Jasmine Street entrance, you will find a more wooded area bordering the creek with more of a freshwater ecosystem in place. It is here you may find more typical forest animals like raccoons, armadillos, tree frogs, snakes and even more birds to observe. You can exit through a raised boardwalk near Sadler Street and return to visit the rest of beautiful Amelia Island.

However, there is an older path just across one of the southern bridges off the Egans Creek Greenway. It is not listed on the site's map. It is not

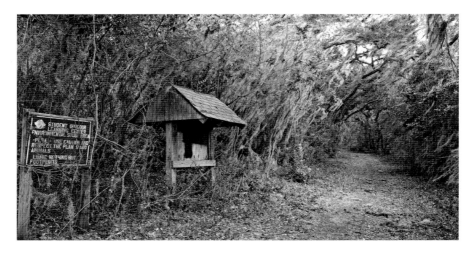

The path to Wiccademus's grave.

listed as even being part of the preserve. There are remnants of a fire circle and even trail markers falling into disrepair. The signs are faded but claim it was a student nature path for education at the high school that is across Citrona Drive. There seem to be no records of it ever being used by the school in any way that we could find. This part of the park houses a third ecosystem consisting of willows and Florida live oaks covered in dripping Spanish moss. This is very old Florida forest at its deepest and darkest. The path's back entrance is a disused trail entrance just across from Fernandina High School. This is the entrance most use to find a place of ancient evil.

The legend here goes back to an undocumented colony on the island in the mid-1600s. Though no records of any colony here exist until the mid-1700s, it is not without reason to wonder if the Spanish or French had an undocumented settlement here. There were many attempts at founding a mission or ministry for the local Indians that had little to no records in the New World. The island is certainly pleasant weather wise, and it was located near a well-traveled shipping lane along the Atlantic coast at the time, with it being less than seventy-five miles from St. Augustine, an undocumented settlement is not out of the realm of possibility. This lost colony, per the legend, had a serious problem with witchcraft.

The story goes that a coven of witches held many rites out among the live oaks. They danced with demons and ensorceled the men of the town to do terrible things. It is perhaps this enchantment that kept the colony from any record keeping. Sometime later, a lone ship of Pilgrims arrived. The town,

under the influence of the coven, forced the Pilgrims back into the waters, where they fled north. Eventually, the town accepted a Pilgrim stranger who had been separated from the rest of the northbound Pilgrims. This young stranger apparently had stayed behind on purpose, as he was gifted with the skill set of a witchfinder. He helped free the colony as he rooted out the coven. This began a series of trials that predated those at Salem by nearly fifty years. When all was said and done, the coven was destroyed with a mass of hangings. At last, there was only one witch left in the town, a little girl.

This little blond-haired girl was pinned as the leader of the coven. She was in control of a pet demon named Wiccademus that she had complete mastery over. This demonic creature could command the winds and rains. It could rend an animal in two with merely a thought. Worst, it could turn men's hearts from God. The girl had to be dealt with and the demon had to be banished.

The legend, as told today, is unclear about the next part, as two versions have been frequently passed down. Either the girl was found guilty and hanged by her neck from a particularly ancient oak or she fled into the woods and the demon hid her away. Either way, the girl and the demon are said to still be in the woods, either buried near a stone marker under a large oak tree or haunting the old student trail. The story has been passed down for as long as anyone can remember at the school.

The story doesn't end here though. There is a curse on these woods, placed by the young witch or the demon in her thrall. The tale is told that if you find the marker at the base of the old oak tree and say the magic name "Wiccademus," you will feel the power of the demon. The power could be a loud booming sound, sudden gusts of wind or even immobilization as the spirit appears before you. The spirit can appear as the little girl, which our eyewitness claims haunts her dreams to this day, or it can appear as the head of the horned demon itself since the beast is too large to see in its entirety.

This has, of course, led to "legend tripping" by students for as long as the high school has existed. Teachers and students told us that students tend to avoid the path for one reason or another, mostly because of snakes and alligators, but brave souls try to see if they can poke at the dangerous legend.

One test of bravery includes spending the night at the site of the grave, which is illegal in the Egans Creek Greenway, as it firmly closes at sunset, but since this isn't claimed by the Greenway, I can see how it is still practiced. We found numerous cans and even signs of a recent fire at the old pit. There are some recent tags and minor scrawled vandalism on the benches from students of the nearby high school.

Is this the stone marker of the grave of the witch?

The second way to test the mythology of this old tale is to speak the name "Wiccademus" three times at the stone marker, like a Bloody Mary ritual. Then the dark energy will spill forth and paralyze you as though you were experiencing a waking nightmare. Shadowy creatures will dance about you and take pieces of your soul. In exchange, you will be granted the powers of the little witch for a time.

Another test of the legend is to walk through this area and see how many times you can say "Wiccademus," for when his name is spoken enough, he will gain enough strength to break free from his imprisonment from the witchfinder of so many years prior. The ground will shake, and the wind will rise into a furor. Thunder may peal, and a booming sound will occur as the demon attempts to break free of his ancient cage.

The final legend states that if you travel there on three consecutive nights, you will dream of the little witch girl. If you then return for a fourth night, she will take your life and your very soul will be fed to her pet demon. There doesn't appear to be an upside to this test.

If you wish to try any of these legends or to simply experience these old Florida woods on the disused trail, your time is almost up. The land appears to have been sold to local land developers, and housing subdivisions are springing up nearby. It is a shame that these old woods will soon yield to the burdens of a growing population's demands on the island, for it truly is a hauntingly beautiful place. So far, no one has unearthed any signs of a lost colony. If any developer has found any sort of a sign of a seventeenth-century settlement on the island, no one is talking.

You have to wonder if someone will eventually have Wiccademus's grave in their backyard or even under their bedroom soon. If you are trying to buy a new house on Amelia Island and get a surprisingly great deal, then you may want to post a sign that says, "Whatever you do, don't say 'Wiccademus' here!"

KINGSLEY GHOST HORDE

Fort George Island

No one is exactly sure how long Fort George Island has been inhabited. It is a marshy island at the mouth of the St. Johns River. There were reports of a long-lost Timucuan Indian village somewhere on the island, but no compelling evidence of it has ever been found other than a few shell middens that dot the island. The early Spanish settlers founded a mission on the island here called San Juan de Puerto, which is where the nearby St. Johns River gets its name. In 1562, French explorers entered the area and founded Fort Caroline as a small colony on the island. The Spanish attacked and destroyed the fort a short while later, as detailed in the story of Fort Matanzas elsewhere in this very book. The Spanish built a fort on the site they called San Mateo and occupied it for merely a year until 1569. While no one is quite certain exactly where Fort Caroline or San Mateo actually were, it is assumed they were on Fort George Island.

In 1763, Florida was given to England by the Spanish, and a large plantation was built on the island by Richard Hazard in June 1765. He turned the island into a successful indigo plantation with his family and their many slaves. John Bartram, the famous botanist and explorer, visited the island in 1766 and spoke of Hazard as a good man and a great planter on an island filled with marsh. Bartram then visited the site of the old Spanish mission San Juan de Puerto, which had been destroyed by British invaders from South Carolina in 1702, and even spoke of the shell middens of the natives still dotting the island as he wrote of his travels in northern Florida.

The plantation passed on to Richard's widow, Phoebe Hazard, and then to his son Richard Hazard Jr. British governor Patrick Tonyn then purchased the property but had little time to do anything with it, as Florida was given to the Spanish in 1783 at the Treaty of Paris, which ended the American Revolutionary War. It would be a decade before John "Lightning" McQueen, a hero of the American Revolution, would be lured here by the Spanish as they tried to get American settlers to come to Florida. They gave McQueen the island in honor of his service in the Revolution. He built a huge mansion on the island and brought some three hundred slaves with him.

McQueen went bankrupt shortly thereafter and had to sell the plantation to John McIntosh. McIntosh tried to resurrect the plantation, which was showing serious signs of neglect by 1804. McIntosh, however, had taken a prominent leadership position in the Patriot Rebellion, which was an insurgency by Americans to speed the annexation of Florida into the neophyte United States. The rebellion was ultimately unsuccessful, so he was forced to flee to avoid reprisals from the Spanish.

The plantation was bought from McIntosh in 1814 by Zephaniah Kingsley, who moved to Fort George Island and built what is known today as the Kingsley Plantation. He brought with him a wife and three children. His wife, Anna Madgigine Jai, was a slave he had purchased in Cuba from Senegal, West Africa. A short while later, a fourth child would be born at the newly built plantation. Marriages between plantation owners and African women were quite common in East Florida. The Spanish government of the time provided for a separate class of "free people of color" and encouraged slaves to purchase their freedom, as slavery was not considered a lifelong condition in Spanish Florida.

Kingsley eventually owned thirty-five thousand acres throughout northern Florida and had several plantations. He also had several concubines or co-wives, with Anna Jai remaining the matriarch and running the main plantation on Fort George Island. Anna oversaw sixty slaves as they grew citrus, sugar cane, potatoes and sea-island cotton. Visitors to the plantation were often invited to dinner, where Kingsley would proudly show off his multiracial family.

When the United States regained Florida from Spain in 1821, things began to turn for the worse for Kingsley. American territorial law was very harsh against the black population, as they feared slave uprisings and rebellions. Kingsley argued against these laws and published *A Treatise on the Patriarchal or Co-operative System of Society as It Exists in Some Governments… Under the Name of Slavery.* President James Monroe appointed Kingsley to

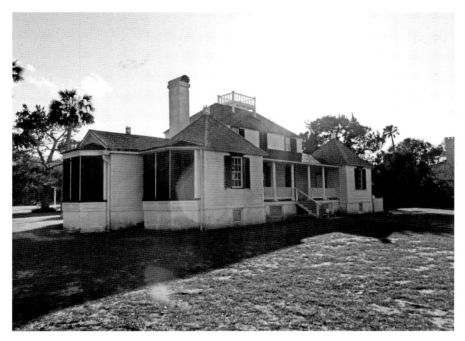

The Kingsley Plantation.

Florida's Territorial Council, where he pleaded his case to define the rights of "free people of color." Disappointed with a lack of progress, he resigned and published his treatise as a response.

One of the most remarkable pieces of information about the Kingsley Plantation is that with a freed black woman as its overseer, the plantation allowed the slaves to continue religious practices of their African heritage, with the added necessity for them to attend Kingsley's Sunday Catholic services. It may be that this was one of the first places where the Houdon religion and the Catholic religion began to blend. Some archaeological digs at the site have found remains of religiously sacrificed chickens and some small but significant voodoo-related relics to back up this claim of early religious tolerance unheard of at the time.

In 1843, Zephaniah Kingsley passed away while on a trip to New York to purchase more land. Anna Kingsley returned to Florida in 1846 after a dispute was brought with some of her husband's relatives. His will had been made under Spanish colonial law, where inheritance by free blacks was legal. The court, in a remarkable ruling for the time, ruled in her favor, and

she regained control of all of her late husband's holdings in Florida, which she kept until selling the plantation in 1852. That year, she and her family moved to St. Augustine, a short distance to the south.

The slave quarters and plantation continued under the new owners until the end of the Civil War. The slave quarters were built out of tabby, an early American form of concrete. There were thirty-two of these buildings stretching in a semicircle split by a road to the plantation main house. Twenty-five of these still remain in some form and are a testament to the sturdiness of their construction. With the end of the Civil War, many of the slaves had nowhere to go and stayed in the quarters for a number of years, still farming the land. Most would move to find better work in the nearby cities of Jacksonville and St. Augustine. Many took on the surname of Kingsley as they became free men, and this name is still common in those cities, as descendants of the original slaves still live in the area.

The plantation passed through a few hands throughout the years, as many tried to farm there. When the freeze of 1894 came, which destroyed so many crops in Florida, new owners tried to turn the island into a tourist destination and built a great hotel. Many famous visitors had come to the hotel, including Harriet Beecher Stowe. The island was becoming a new cultural mecca for early Florida tourism.

It was here that the odd stories of the island begin. As stated in some legends of the area, the African rituals had offended some of the older

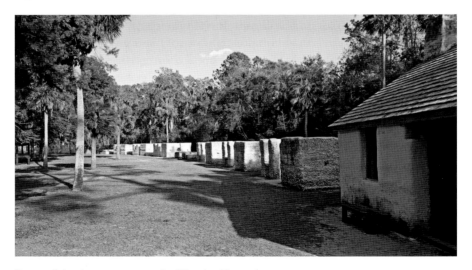

Some of the slave quarters at the Kingsley Plantation.

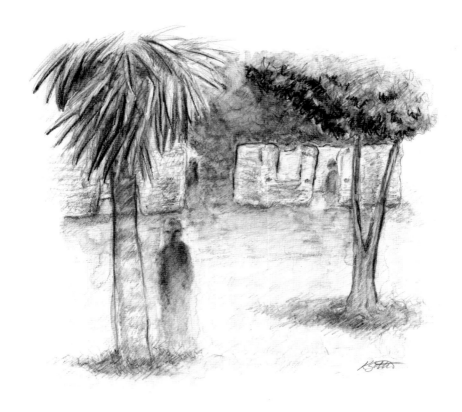

The shadowy ghosts of the Kingsley Plantation. *Illustration by Kari Schultz, 2017.*

Indian spirits of the island. The new hotel was seen as a further affront to this scenic and pristine wilderness. While the farming was continuing on the island, this war of spirits was not escalated. With the dramatic shift to a tourism-based focus, the spirits of the island's many dead were becoming restless and wanted no more visitors.

In 1887, a strange mob of shadows was seen on the island moving through the marshes, and many feared a new Indian uprising or possibly an unknown invading army. Perhaps even the former slaves were coming back to claim their rightful property. Not much was thought of it until a mysterious fire a few nights later burned the hotel to the ground. Eyewitnesses said dark shadows could be seen watching the fire from the trees and even in front of the old tabby houses.

A few more attempts at building private clubs and other cultural centers failed over the years, and the plantation was purchased by the state in 1955. It was eventually included in the Timucuan Ecological and Historical Preserve, which also houses the estimated remains of Fort Caroline, the remains of the Spanish mission San Juan del Puerto and the plantation house and the surrounding slave quarters. It is a beautiful place to visit but still a solemn reminder of the institution of slavery in the early history of the United States of America, though perhaps here it may have been a bit more culturally tolerant than elsewhere.

To this day, there are stories of strange black shadows marching through the trees at night. Boaters say they can be seen standing on the shore of the island, swaying like a line of mangroves at the water's edge. Other tales say that you can see shadowy slave families still around the cabins. You can even hear chanting and voodoo drums echoing throughout the marshes. Will this veritable horde of ghosts ever truly find peace, or are they just another mirror into the past of Fort George Island and the Kingsley Plantation?

TOMOKA PARK'S
FLESH-EATING CLOUD

Daytona

Just about fifteen minutes north of Daytona Beach lies the beautiful Tomoka State Park. It is far enough from city lights to give visitors a view of the most beautiful night skies in all of Florida. This nine-hundred-acre peninsula was the provider of much food and shelter for the earliest inhabitants of the area and still offers a nourishment to the soul and senses as a beautiful park.

On this spot in the early days of Spanish exploration of the Florida coast, the Spanish found an early Timucuan village called Nocoroco. Apparently, Chief Tomokie of the local tribe was intrigued with the new visitors. They claimed to be seeking a fountain of youth that was rumored to lie in the area, along with lost cities of gold. Tomokie knew the legend well, for his people had a sacred spring that was never allowed to be drawn from. There was also a sacred golden cup that was only to be used by the shaman to draw waters from the river to bless crops at the appropriate times.

Eager to please his guests while also wondering if the legend of eternal youth might be true himself, Tomokie grabbed the cup and drank from the spring. The Spanish leader then seized the golden cup and drank heartily from the sacred spring. This angered many of the tribe, and Tomokie realized too late what an error he had made. The Spanish guessed there was more gold to be had and began to ransack the village in search of treasure.

The entrance to Tomoka State Park.

Tomokie and his warriors finally repulsed the Spanish via sheer numbers and tried to restore their village.

A tribal war broke out as word spread of Tomokie's violation of the sacred spring. Local tribes clashed in a series of battles near the village, but Tomokie supposedly was unhurt during all of it due to the healing nature of drinking from the spring. The legend states that he could not be killed by any man.

The legend continues that a young Indian maid named Oleeta from one of the neighboring tribes took up arms with her brothers as they went to slay Tomokie. As she was "no man," her bow shot straight through the heart of Tomokie. After the chief was slain, she went to retrieve her arrow and found the golden cup lying at his feet. When she pulled the arrow from the fallen chief's heart, a drop of Tomokie's poisoned blood somehow got on her hand. She died just as she picked up the cup. The tribes knew of the poison now and buried Tomokie's body deep in the woods of Nocoroco.

Today, all that remains of the village are the shell middens, mounds of oyster and snail shells from decades of Timucuan meals that reach nearly forty feet high at the river's edge. The cup is supposedly held by one of Florida's native tribes to this day. Tomokie and his poison are not forgotten.

In 1825, Thomas Dummitt bought a plantation near the area of the mouth of the Tomoka River, not far from the remains of Nocoroco. He then proceeded to build a rum factory and sugar mill closer to the river for ease of trade. It was the first steam-powered sugar mill in Florida. A furnace was used to heat sugar cane from the nearby plantation into juice and molasses. As the juice boiled, it was skimmed off by hand and placed in a cooler kettle to eliminate the impurities. The resulting syrup was hardened and processed into the crystalline form of raw sugar. The bulk of the juice was shipped off to the Caribbean to be used in the manufacturing of rum.

The furnace served a dual purpose, as it also powered a boiler that created steam to power the machinery that helped squeeze the juice out of the sugar cane. It worked well for a time, but the Indians knew Dummitt was getting

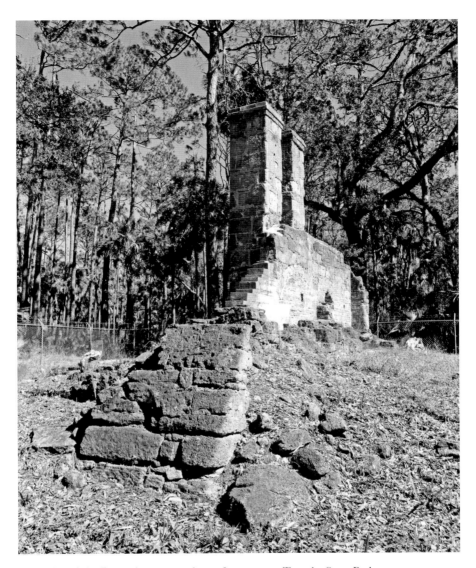

The ruins of the Dummitt sugar and rum factory near Tomoka State Park.

water from the sacred spring. In 1836, the factory was attacked and burned during the Seminole War. All that remains of the factory now is a chimney and signs of the slough.

This is where the story gets eerie. Reports began to surface of will-o'-the-wisp-like lights and a strange pink mist that would travel along the roads

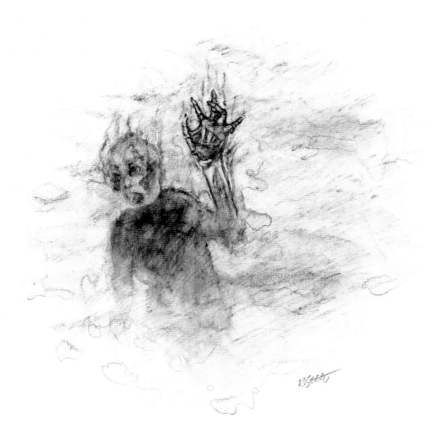

The poison cloud of Tomoka claims an unwary victim. *Illustration by Kari Schultz, 2017.*

running along the banks of the Tomoka River. These lights would form out of nowhere along the road and break into multiple lights. Sometimes they would fly over the car; other times they would split and go around it. Eyewitnesses describe them as white lights of intense brightness and smaller than a car headlight. Locals insist that if the lights make contact with you, they will sear your flesh. A few talk of a couple who were forced into a deep slumber by the lights and then hit by another vehicle as their car rested on the roadside. Their ghosts are now added to the haunted legend of the lights of Tomoka.

There are numerous versions of stories of the lights, and they stretch all the way to Deltona. Some people claim that the lights now reside alongside I-4 and will lull drivers into a slumber with the possibility of a crash. Some witnesses claim to have been awoken by passing cars on I-4 with hours of their lives missing and not remembering pulling over to stop. The highway patrol does note the area has a high number of "wake-up calls" for slumbering motorists. That is unusual in itself, as the area is only minutes from the big cities of Daytona and the greater Orlando area, including Sanford.

Many believe the phenomenon was merely swamp gas or reflections of lights from the roads, as the Tomoka bridge was being rebuilt at the time of the sightings in the mid-1950s. With the migration of the legend miles away to Deltona, recent sightings are few. People do still go legend tripping hoping to see the lights at midnight on the road to Tomoka.

The legend gets weirder still. From 1955 to 1966, numerous reports claimed a strange fog bellowed forth from the park. The cloud hung low to the ground like a strange pink mist. Once again, the rumors said that disturbing the sacred spring while building the bridge brought forth the ghost of Tomokie and his poisoned blood. Many disappearances were blamed on the cloud, and it was rumored to be carnivorous. It was said that touching the cloud would cause it to eat the flesh right off your bones.

Deer hunters claimed to come upon the cloud at the height of deer season and say it cleaned the flesh right off the bones of a deer they had been tracking for hours. Many said it was a cloud that issued forth from the haunted ruins of the Dummitt factory; others claimed it was Chief Tomokie's cursed spirit that was rising to protect the spring from intruders.

There are no further reports of the cloud after 1965 as far as we can see. The area itself is now well developed with new homes and communities. If it was simply swamp gas and reflecting lights or industrial pollution from so much construction, we may never know. It still draws locals and tourists alike looking for the odd lights and pinkish cloud, hoping for contact with aliens, the paranormal or something in between.

"Pinky," the St. Johns River Monster

Jacksonville

From the Highlands of Scotland to the Great Lakes of North America, river monsters and cryptozoological beasts of legend have haunted the psyche of many seeking out the strange and unusual. Of course, Florida's deep swamps and twisting rivers have so many legends of giant alligators, colossal snakes, unusually large birds and even our very own versions of living dinosaurs. The most famous of these is the St. Johns River Monster or, as it is known by many, "Pinky."

The legends date back to the early 1880s with the early expansion of settlers into the state after the long and bloody Civil War. River monsters were nothing unusual then, as tales of giant snakes and alligators were spread by the newspapers of the state in an attempt to sell their stories to a wider audience.

One article from the *Fort Myers Press* in southwest Florida from the year 1888 talks of a large snake swimming across the Caloosahatchee River near Chokoloskee. Two men, including a former colonel from the Civil War, spied the large snake-like creature crossing the river at a wide point and saw its head about four or five feet above the land on one side of the river while its tail was dragging across the water. As the area was not known for large snakes, they reported it immediately. It would have been nearly sixty feet long with a body about the size of a flour barrel, according to their description. The paper learned from local Indians that

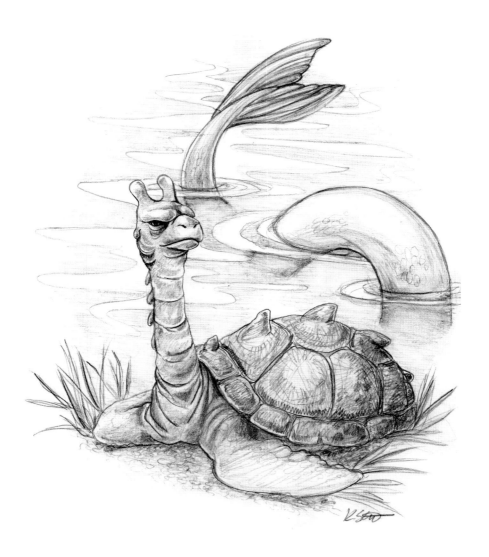

Could this be what Pinky really looks like? *Illustration by Kari Schultz, 2017.*

they had legends of a giant snake near that swamp, so they stayed clear of that area altogether.

Today, there are numerous large snakes near that swamp, as exotic pet owners sometimes released boa constrictors and pythons into the wild. These invasive species have thrived in the warm climate of southern Florida.

View from the Lake Monroe Bridge, where the St. Johns River Monster has been sighted several times.

They have become a serious threat to the delicate ecosystem of Florida's wetlands. Frequent hunts are allowed in the state to get rid of these creatures, with bounties posted by the state for especially large kills. That said, the aforementioned snake legend occurred over one hundred years before this became an issue.

Many of the sightings of the more modern monster known as the St. Johns River Monster occurred in the 1950s and 1960s. The new highway systems were running smoothly, and tourists were flocking to the state. Newspaper articles from the period included reports of an unusual creature being spotted by local fishermen and tourists. This creature was described by some as a large manatee with a pinkish skin, perhaps an albino. There were some reports that it only had a pink tail and head, and the rest of its body was gray and elephant-like. There were even some reports of a dinosaur-like creature walking on two legs with a large tail behind it. Two bass fishermen claimed the creature had nearly overturned their boat.

When the press descended upon the area, they discovered that this new monster had a long history in the area and maybe wasn't so new after all. The famous naturalist William Bartram first journeyed these rivers in 1774 and sent early reports of alligators and manatees back north. His guide, however, cautioned him that these creatures were quite ordinary but to "beware the beast of the deep" as they traveled the St. Johns River. He reported seeing fiery dragons somewhere in what is

now Volusia County on an island that many believe is where the famous lighthouse now stands.

In August 1896, the *St. Francis Gazette* reported that some large creature had overturned a fishing boat near Lake Monroe. Shortly thereafter, another report came from the steamer *Osceola* when some large creature under the lake ran into the vessel and caused much concern.

In 1949, the *Jacksonville Gazette* even published a drawing of what was then known as "The Lake Astor Monster" in one of its issues. A river guide described it to the sketch artist, as he had seen it numerous times along the winding path of the St. Johns. This drawing resembles the classic Nessie look of a living dinosaur and may have been influenced by the Loch Ness Monster mania occurring at the time.

In 1956, strange footprints were discovered in the mud along the banks of the St. Johns River up from the appropriately named Lake Hell'n Blazes. The prints were described as being about ten inches long and reptilian, with three toes pointed to the front and two to the rear. At this point, the stories were so varied that it became difficult to determine if it was one creature or a series of unusual animals that tourists were not used to seeing, like an unusually large manatee or perhaps even an extremely large albino alligator. Some reports even spoke of the creature having horns or a lone solitary horn like a narwhal.

An *Argosy* article spoke of a a young biology student named Mary Lou Richardson who, in the 1960s, was out hunting with her father and a friend. They saw a very unusual animal that they described as a donkey-sized dinosaur with a giant flat head and a rather small neck Four other groups of tourists reportedly saw the creature as well. Local fishermen and hunters

seemed to know this creature very well and were not surprised by it. This article was written by cryptozoologist Ivan T. Sanderson, and he theorized that the St. Johns River was home to a living dinosaur.

In the late 1960s, it was reported that a fishing guide and two of his clients had spotted a large creature that was the size of an elephant walking along the bottom of the St. Johns River near Lake Dexter. The creature was so large that it was clearly no manatee. They followed it for a time before it sank beneath the surface.

The sightings died down for a time, but in 1975, Charles and Dorothy Abram went fishing with a few friends along the St. Johns River. It was there that they spotted the head and neck of a large pink animal surfacing around twenty feet from them. The creature turned its head to look at the fishers and then quickly submerged within a few seconds.

Dorothy was quoted as saying it looked like "a dinosaur with its skin pulled back so all the bones were showing…pink, sort of the color of boiled shrimp." The description was incredible. A giant reptilian lizard, pink in color, with the bones showing through a translucent skin. The creature's head was human sized and had small horns protruding from the top with knobby tips. It had flappy skin on the sides of its head. It had a three-foot-long neck and slanted dark eyes like those of a shark. The creature may have had a large turtle-like shell on its back, as they described the hump as being less pinkish and greener as it dove back into the water. The nickname of "Pinky" stuck almost immediately as the newspapers of the time printed the story.

Of course, all of these sightings could not be the same creature. A dinosaur with a flat head that walks on its bipedal legs, a more traditional long-necked sea-bound dinosaur and big creatures ramming boats have all been reported as the St. Johns River Monster. The creatures sighted have been called various names coming from the surrounding lakes, including the Lake Monroe Monster, the Lake Astor Creature, the Beast from Hell'n Blazes and some still simply being Pinky. Tourists unfamiliar with manatees and alligators are surely to blame for some of these sightings. Being startled by an albino dolphin is enough to give you a monster tale for years if you are a fisherman.

Could they all simply be misidentification? The land sightings of dinosaur-like creatures must evoke some sense of unusual life. Some zoologists have theorized that it might have simply been an albino seal that came in from the Atlantic. Others have claimed it might be an undiscovered species of giant salamander. Whatever the case, keep your eyes open as you travel along the bridges and banks of the St. Johns River and its many lakes that coil through Florida like a giant snake.

THE GHOSTS AND
THE EXPLODING BISHOP

St. Augustine

*B*eing the oldest European settlement on the North American continent—it even predates Plymouth Rock by over sixty years—St. Augustine has its share of dark history. Conquistadors, pirates, mass graves, murderers and so much more fill this city with legends, ghost stories and as much history as any city in Europe. Is it any wonder that it is considered one of the most haunted cities in America?

Though known for its amazing beaches along the Atlantic coast in this tropical paradise, the city's heart is its historic district wedged between Flagler College at the historic Ponce De Leon Hotel and the waters of Matanzas Bay and the famous Bridge of Lions. From the Castillo de San Marcos that overlooks the bay, to the shops on St. George Street where tourists flock to buy trinkets among the buildings that date back before the founding of America, on every corner are tour guides willing to tell you all the wonderful history. Amazing restaurants are nestled in with confectioners and tacky tourist shops. All of these lie among truly historic buildings, including the oldest schoolhouse in North America, Ripley's original Believe It or Not Museum and the oldest house in North America.

Historic festivals fill the calendar with year-round celebrations and events. Many of these commemorate legendary events with reenactments and religious ceremonies. One can enjoy arts and craft fairs, seafood festivals, colonial celebrations, Native American rites and torchlight parades. From

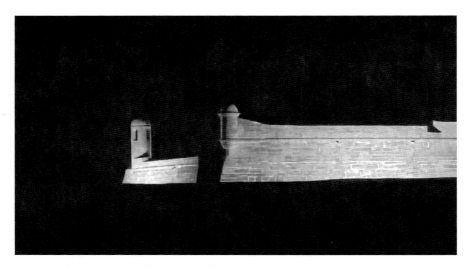

The Castillo de San Marco in St. Augustine by night.

November through January, St. Augustine is quite literally aglow with millions of white lights by celebrating "The Nights of Lights" throughout the holidays. You can even travel a couple of miles to the location of the Fountain of Youth, according to Ponce de Leon. To go and drink from the fountain is as easy as asking, once you pay a few dollars for parking and admission. The water is super sulfuric and smells terrible, by the way.

A place so rich in history has so many wonderfully dark and macabre tales surrounding it. The old Castillo alone houses a ghostly pirate looking for his head, a couple sealed into the very walls in a lost room for centuries and phantom soldiers that march along the battlements to this very day.

The gates to the old walled city still stand as they face the public cemetery known as the Huguenot Cemetery. This graveyard was used for Protestant burials from 1821 until 1884. As St. Augustine was a Spanish city, only Catholics were allowed to be buried in the cemetery inside the town. With the annexation of the Florida territory into the fledgling United States in 1819 with the signing of the Adams-Onis Treaty, there came the loss of St. Augustine from the Spanish. As there was now a need for a formal Protestant burial ground, the new American leaders of the city chose the area just outside the city gates. Shortly after it opened, a yellow fever outbreak gripped the city, and the cemetery filled very quickly. The spirit of the daughter of the gatekeeper is said to hide near the gates

and warn people about "Yellow Jack." She warns travelers, particularly fellow children, to stay away from St. Augustine.

A short drive across the Bridge of Lions and the bay leads you to St. Augustine's famous lighthouse. The ghosts here are also numerous and include an old lighthouse keeper and his two daughters who died while riding the rails that dragged stones to build the very lighthouse they haunt.

Naturally, there is a booming industry in ghost walks, paranormal tours and even haunted carriage rides. The haunted pub tour is a great way to experience local spirits in one way or another. There are even tram rides that take you across the bay to the haunted lighthouse and back across to visit the old jail and the other ghost-filled locations in St. Augustine. The Sheriff's Ghost Walk is probably the best bang for your buck for entertainment, history and some of the best storytelling you will ever hear. It is hosted by Doug Stenroos, who plays the role of the ghostly legendary lawman Sheriff Guy White. He's well worth the price of admission and getting deputized so that he can lead you through the haunted streets and alleyways of St. Augustine.

The bed-and-breakfast business is also booming in St. Augustine, and many of these places love to cash in on ghost-hunting tourists looking for a little extra fright with their warm breakfasts. The St. Francis Inn may be the oldest such operation in America, as it goes all the way back to 1791, when Anna Dummitt turned her family home into lodging for visitors to St. Augustine. The inn itself has hosted guests for ages and can still be booked for rooms today. If you want to be scared, make sure to ask for "Lilly's Room."

The story goes that in the mid-1800s, a soldier, Major William Hardee, owned the St. Francis Inn and lived there with his young son. There were several servant girls in the house, including a young beautiful slave from Barbados named Lilly. The tale says that Lilly and the young son fell in love and started having trysts in the various rooms of the house while the major was away on business. They apparently got more brazen and would eventually sneak off when they thought they had even a moment to themselves. Sadly, this joy was short-lived, as the major apparently caught the young lovers. The legend is unclear at this point. Some variants of it claim that the father had the servant girl sent back to Barbados. Some say he secretly had her killed. Other versions say he killed her on the spot. The son's fate is rather murky as well. Either he killed himself by hanging himself in his room on the third floor or he jumped out the window there to his death. Either way, it is a tragic tale.

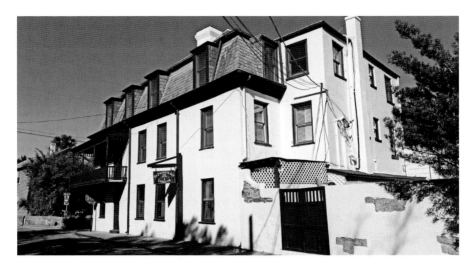

The St. Francis Inn in St. Augustine.

Now, guests of the St. Francis Inn experience all manner of ghostly disturbances and encounters with the paranormal. The bulk of these phenomena are reported in Lilly's Room. Ladies find their purses overturned in the sink with the water running all over them. Lights and televisions go on and off, and mysterious noises are heard. One guest found himself trapped under the bed and had to get assistance to extract himself. One newlywed woke up from a passionate kiss only to find her husband still asleep beside her. Initially, the owners of the hotel tried to hide these stories and its dark spot in history, but with the boom in paranormal tourism, they now embrace it. They offer Paranormal Nights, host investigations and even encourage others to tell tales of encounters with the ghosts of the St. Francis Inn.

A short distance away from the wonderful St. George's Street lies the original town cemetery. Tolomato Cemetery is the original Catholic graveyard in the town. Located on the site of an early eighteenth-century Franciscan Indian mission called Nuestra Señora de Guadalupe de Tolomato, or Our Lady of Guadalupe of Tolomato, the cemetery houses the final resting place of over one thousand denizens of St. Augustine's history. It is named for a river near where the Guale Indians, who had fled to St. Augustine sometime in the sixteenth century, had originally lived somewhere in Georgia. The cemetery saw the burials of many up until

1884, when the city closed it and all cemeteries within the city walls for future burials for fear of another outbreak of yellow fever.

Numerous burials of historic significance are located in Tolomato. The cemetery contains within its walls the graves of the first Sisters of St. Joseph. There are graves of veterans who represented both sides of the Civil War, including those of freedmen who fought with the Union. It houses the burial site of important political leaders from the past like Governor Enrique White of the Second Spanish Period. General Georges Biassou of Haiti lies interred here as well.

Father Felix Varela of Cuba lies here in the small white chapel at the back of the cemetery. The father is in the process of canonization to sainthood at the time of this writing. He was buried at Tolomato in 1853. This distinctive feature of Tolomato, the chapel, was built to hold his remains by Cubans who had been his students in the seminary in Havana and friends of his in New York City.

Again, with so many graves and history, is it any wonder that there are numerous ghost stories and legends about a cemetery that is less than an acre in size? A ghostly boy is seen playing among the tombstones. A lady in white is seen wandering the stones by moonlight. A cadre of phantasmal Spanish soldiers lies in wait behind its walls, dodging fire from some ancient cannon attacks. The trees themselves have legends of lives and loves both won and lost.

No one even knows how many are truly buried here; there are over one thousand recorded burials based on the parish death records held by the diocesan archives in what is now the Cathedral Basilica of St. Augustine. The cemetery is still owned by the cathedral parish and the Diocese of St. Augustine, which have maintained and protected it over the years. With all of those burials, why are there fewer than one hundred markers? The Indians also buried their dead here long before the Catholics claimed it as their own burial ground. Just how many are here is one of the many mysteries of Tolomato.

The story of one burial here stands out above all others thanks to a bust of the occupant of the plot before it. The grave lies at the very heart of the cemetery and houses the remains of Bishop Augustin Verot. Born in LePuy, France, in 1804, Bishop Verot was essential in building several churches in the early days of Florida. As the third bishop of the Diocese of Savannah, Georgia, from 1861 to 1870 and the first bishop of the Diocese of St. Augustine, Florida, from 1857 to 1876, Bishop Verot helped advocate the state as a health resort and promoted many of its products and cultural

history. He was an influential figure during the social upheavals of the state, particularly during the Civil War and the Reconstruction period soon thereafter.

Bishop Verot, a beloved figure by many in the church and as a calm head in the years following the Civil War, published a pastoral letter telling members of the church to "put away all prejudice…against their former servants." He advocated a national coordinator for evangelization among blacks. He then sent word to his original home in LePuy, France, to seek sisters to work with the evangelized former slaves. His sermons and speeches were printed and spread among newspapers far and wide.

When Bishop Verot died in 1876, it was no wonder that thousands wanted to see him and attend his funeral. With travel times so great and visitors coming from half a world away, there was a need to keep the body on display for some time. It was mid-June in Florida, and it was ungodly hot. Here is where legend and history get a little blurry.

The bishop's remains would need to be visible to mourners, but to keep the heat and bugs away for so many days, it was decided to put him in a metal casket, which was a new procedure at the time. A glass window

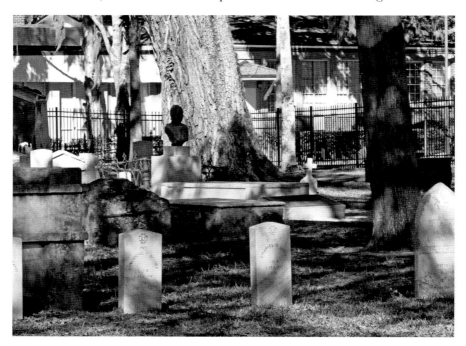

The grave with bust of Augustin Verot in Tolomato Cemetery.

would be secured so that the body could be viewed. Some stories say that ice was shipped in to be placed in the casket as well to help preserve the body. Embalming was still fairly new after only starting to gain popularity during the Civil War. The church was still partially against the practice, so the ice packing method in the steel coffin was agreed upon for Bishop Verot.

Days passed in the Florida heat, and unbeknownst to those arranging the viewing, gases were forming in the airtight coffin as the decomposition of the bishop had begun. The combination of the pressure and quickly melting water from the ice was steaming the body like a pressure cooker. The day of the funeral finally arrived, and everyone gathered in the basilica for the service, with Bishop Verot in state for all to see.

When the explosion occurred no one really is certain. In some stories, it was during the ceremony; others say just after. The glass cover gave way to the pressures of the gas, and the bishop exploded all over the basilica. There are stories of fleeing funeral attendees flooding into the streets of St. Augustine from the cathedral. Sometime later, volunteers went in and collected the remains and cleaned the church. What was left of the body was reinterred within a fully metal coffin with no glass cover, and he now lies under a large slab of concrete in the dead center of Tolomato. A bust of his image stands tall in Tolomato for those who wish to view him now.

With so much history in one town, is it any wonder that there are so many excellent books about its rich legends and historical accounts? We highly recommend *Hidden History of St. Augustine* by Drew Sappington and *Haunted St. Augustine and St. Johns County* by Elizabeth Randall; both are also available from The History Press. Or better yet, visit St. Augustine yourself. Tour the historic sites or visit the eclectic museums like the Pirate and Treasure Museum or Wolf's Museum of Mystery. Take one of the many ghost tours or maybe even walk with the Sheriff. Just be sure to tell him *Eerie Florida* sent you.

THE SLAUGHTER OF FORT MATANZAS

Anastasia Island

*I*f you follow A1A just south of St. Augustine, you will travel along the shore of the Atlantic Ocean and see some breathtaking views of the water and its white sandy beaches. Multimillion-dollar homes and condos line the coast. As you pass by bait shops, boat ramps and beach bars lying among the mansions, it is easy to forget that this was once simply a wilderness.

Nearly twelve thousand years ago, before Europeans came to "La Florida," the early inhabitants fished and used the local rivers to survive in the mild climate of tropical Florida. These people are called Paleo Indians and are the oldest indigenous Indians known. They used hollowed-out log canoes and thrived in the area for thousands of years. Eventually, they would tend to settle near the mouth of what is now called the St. Johns River. They developed a very specific culture and became known as the Timucua tribe.

The area around what is now Matanzas Inlet was called Dolphin Bay. The waters were rife with fish and oysters. Archaeologists have learned from the shell middens of the Timucuan Indians that the people prospered for centuries here. The inlet, the river and the ocean provided a perfect home.

In 1562, a French explorer named Jean Ribault landed somewhere near Amelia Island and met Timucuan Chief Saturiwa. He had this to say of the encounter in his writings: "They be all naked and of goodly stature, mighty, faire and as well shapen…as any people in all the worlde, very gentill,

curtious and of good nature….The men be of tawny color, hawke nosed and of a pleasant countenance….The women be well favored and modest."

The tribe helped the French settlers adapt to the unique conditions of their area of the New World. The Timucuan Indians even went so far as to assist them in building their village and an early fort, which they called Fort Caroline. The French were very grateful for the assistance and went well out of their way to avoid damaging their relationship with the local tribes. Sadly, when starvation began to rear its ugly head among the French settlers, the peace unraveled quickly, and armed conflict began with the natives.

Back in Spain, King Philip II learned that the French had established Fort Caroline in La Florida and was enraged. A colony of Huguenots (French Protestants) now existed on land that belonged to the Spanish Crown. Not only that, but that land was also sacred to the Catholic Church. Philip protested to the King of France but was rebuffed. Word arrived that the Frenchman Rene de Laudonniére had sailed from France in May 1565 with more than six hundred soldiers, supplies and even more settlers, further establishing Fort Caroline.

Angry at this turn of events, King Philip ordered General Pedro Menéndez de Aviles to sail and remove the French from La Florida once and for all. The general and his forces set sail later that same month with some eight hundred men. A brief sea chase between the French and Spanish forces occurred near the coast of America. The Spanish realized that the French vessel was too agile and quick, so they sailed south to a Timucuan village named Seloy. When they came ashore on September 8, they established their new village and dubbed it "St. Augustine," as they discovered the site on August 28, the day of Saint Augustine.

On September 10, Jean Ribault set out with a force of French soldiers by sea with the intent to wipe out the new Spanish settlement. A late-season hurricane blew in and forced his ships far to the south of St. Augustine, where they wrecked somewhere along the Florida coastline between modern Cape Canaveral and Daytona Beach. While the French were at sea, Menéndez led his men north to assault Fort Caroline. With the settlement and fort short-handed, Menéndez captured the settlement with ease, killing most of the men. The women and children were sent by ship to Havana. Some men escaped by boat and returned to France, including de Laudonniére and the artist Jacques LeMoyne.

The Timucuan Indians, no friends to the French, informed Menéndez that there was another group of Frenchmen on a beach just a few miles south of St. Augustine. Menéndez took a group of soldiers and marched

with them to where the inlet blocked the shipwrecked French sailors from returning to Fort Caroline.

Using one of the captured Frenchmen from Fort Caroline, Menéndez told these 127 trapped French sailors and soldiers about the capture of Fort Caroline. Having been starving and lost in the Florida wilderness, the Frenchmen surrendered. Menéndez then demanded that they renounce their Protestant faith and accept the faith of Catholicism. The prisoners refused, and 111 men were beheaded in the waters of the inlet. The few who were spared had either professed to be Catholic, were Bretons who had been impressed into service by the French or were artisans sorely needed by the new town of St. Augustine.

In less than two weeks, the same sequence of events occurred again. More French survivors had been trapped at the same inlet, including Jean Ribault himself. On the night of October 12, Ribault had his men surrender to Menéndez, and again they were told to renounce their faith. Refusing, 134, men including Ribault, were executed, and their bodies were thrown into Dolphin Bay. From that day forward, the inlet was called Matanzas, which means "slaughters" in Spanish.

In 1568, the French came back to recapture Fort Caroline. They succeeded with the help of unexpected allies: the Timucuan tribe. After having remained neutral during the Spanish attack in 1565, they actively assisted the French.

King Philip II greatly praised Menéndez for his handling of the French Huguenots. The king of France, Charles IX, had so little love for his Huguenot subjects that he cared little about the matter himself, as did most of the nobles in his court. The people of France were incensed but could do nothing.

There was one Frenchman, however, who was so incensed that he planned revenge for his countrymen. Dominique de Gourgues had been captured by the Spanish as a boy and made to work as a galley slave. He was treated with great cruelty by the Spanish, and he had never forgotten them. It is not known if he was Catholic, Huguenot or even if he believed in any higher power. What is known is that he was ready to avenge his honor and that of France.

Keeping his desire for vengeance a secret, Dominique planned an expedition for the purpose, he said at the time, of capturing slaves across the African coast. He borrowed funds from a brother and sold all that he owned to finance this expedition. He sailed in 1567 with nearly two hundred crew members and encountered very stormy seas until they reached Cuba. Once

there, he told his men the true nature of the voyage, which was to revenge Fort Caroline. His crew was also eager for vengeance, so they forgave the deception and demanded to set forth immediately.

The Spaniards were now well defended in the area, with the Castillo well under construction at St. Augustine and the new San Mateo fort that had been constructed on the site of Fort Caroline. Even smaller forts now dotted the coast at river mouths and banks.

The French had with them a friend of the Indian Chief Satouriona, and he was sent forth in a boat to try to broker peace with the Indians. The chief was very happy to see his friend and welcomed the French back with open arms. The Spanish had been particularly cruel to the Indians. They had been robbed of food, driven from their homes and even had their children slaughtered, all because they had originally helped the French.

A young French boy named Pierre de Bre was brought forth. He had survived the massacre at the Matanzas Inlet and had been found and cared for by the Timucuans. With the assistance of the Indians and the boy, a great war council was called with all the neighboring tribes, and a plan was made to assault the forts to the north.

When the day came, the Indians came by land and the French by sea. When they met, the Spanish were caught completely off guard. Once one of the small forts was retaken, the forces regrouped and attacked San Mateo. The garrison there was so scared by the large number of men attacking them that the commander fled with his men. Some escaped, but most were captured and killed.

Years before, when Menéndez had captured Fort Caroline, he had hanged some of the men from a tree. He then wrote on the tree, "This is done, not as unto Frenchmen, but as unto Lutherans." On the same tree, de Gourgues also hanged certain Spanish prisoners and placed another inscription on the tree. It read, "This is done, not as unto Spaniards, but as unto liars, thieves and murderers."

With St. Augustine too well fortified and the three forts to the north fully engulfed in flames, de Gourgues bid farewell to his Indian allies. His ships of vengeance sailed back home to France. He was greeted warmly by the people as a great hero, but King Charles IX and the royal court were not so pleased. Philip II of Spain demanded the head of de Gourgues, forcing the Frenchman into hiding for many years. Queen Elizabeth invited him years later to join her service, but by that time, Charles the IX had restored him to honor. He died in 1593, shortly before he was to command a Portuguese fleet against his favored enemy, the Spaniards.

Sadly, by this time, the Timucuan culture was rapidly disintegrating. Where the tribe had once numbered in the tens of thousands, only an estimated 550 Timucuans were still alive by 1698. After driving out the French, the Spanish had imposed tribute on them and had forced many into missions. Diseases brought by the European settlers as well as attacks by other Indian tribes had paid a terrible toll. As of today, there are no known Native Americans who call themselves members of the Timucua tribe.

By 1569, the Spanish realized that St. Augustine had a backdoor vulnerability at the Matanzas Inlet, so they built a wooden watchtower to guard it. It was mostly there to send warnings back to St. Augustine. Several times this watchtower saved the town to the north from both British and pirates.

In 1586, the British attacked the town of St. Augustine with a raid by Sir Francis Drake, who burned the town. New English settlements called Georgia and Charles Towne had been founded to the north. The Spanish knew it was only a matter of time before war in Europe would expand into this New World.

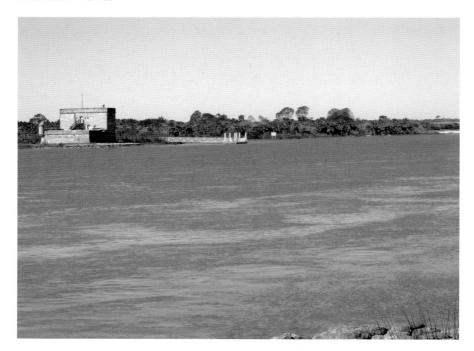

A view of the fort from the shore across the Matanzas Inlet.

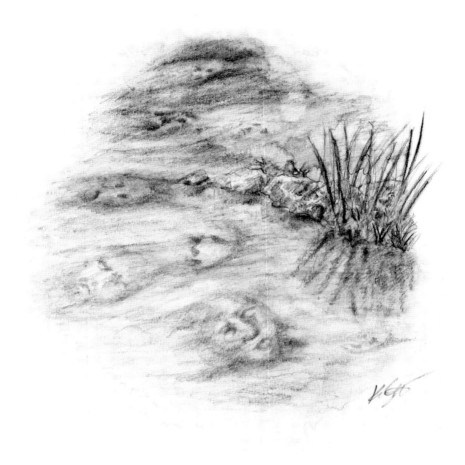

The faces of the slaughtered French lie just under the surface of the Matanzas Inlet on moonlit nights. *Illustration by Kari Schultz, 2017.*

The Spanish then built a smaller fort using the same coquina used to build the Castillo de San Marco in St. Augustine to the north. The fort was then occupied to watch for British or French incursions and even the occasional pirate attack. Fort Matanzas was born.

The fort saw some use over the years. It passed to the British with the stroke of a pen in 1763, as the Spanish gave up Florida after the Seven Years' War to retain Cuba and the Philippines, which they felt were more valuable colonies. Britain maintained the fort, and with the impending

American Revolution, they staffed it with more cannons and men than the Spanish ever had.

Years later, after the Treaty of Paris ended the American Revolutionary War, Florida was returned to Spain. Unable to get many Spaniards to return to Florida, the fort at Matanzas went into disrepair. After 1821, when the Adams-Onis Treaty turned Florida over to America to settle debts of Spain, the fort was never manned again. On October 15, 1924, President Calvin Coolidge named Fort Marion (the Castillo de San Marcos) and Fort Matanzas national monuments.

Now a state park with a ferry that shuttles tourists from its visitors' center to the fort, Fort Matanzas is a sleepy and beautifully restored piece of early European history in America. However, there is a modern dark twist to this tale of massacres and rivers filled with headless corpses.

Many fishermen love this inlet, for it is filled with oysters and the fish that feed off of them. It is the same draw that brought the Timucuans here. Few will stay on the inlet after dark, and never on nights of the full moon in late October. You see, on those nights it is said that the waters turn blood red again, and the faces of the slain French can be seen in the water. One fisherman told us that his wife refuses to even set foot on their boat anymore after one fateful night in October when she went above deck to look at the beautiful moon on the water.

"I'll never forget her face as she described seeing the men staring at her with cold, dead eyes just under the red-stained waves," he told us. Wishing to remain anonymous, he still fishes the inlet, as the fish are "just too easy to catch here." Even he won't stay after dark, though. "I may like to fish, but I ain't stupid." We were unable to find a captain willing to take us out to the inlet on those nights to try to test this legend at the time of this writing.

As a special note to this story, we must mention that the Timucuans hold a very special place in the early European concept of Native Americans. French colonist and artist Jacques le Moyne de Morgues sketched the Timucuan customs and ceremonies, which were some of the first views of Native Americans to the Europeans. Priest Francisco Pareja made a translation of a set of Spanish catechisms and confessionals into Timucuan in 1612. This was the first translation involving a Native American language. It is sad that only their middens and legends remain.

DEVIL'S MILLHOPPER

Gainesville

*F*loridians are no stranger to sinkholes. They are perhaps the biggest threat besides hurricanes to property and even life. These geological hazards occur due to the entire state of Florida being underlain by limestone, a rock that is slowly dissolved by weak acids found in rain and in the porous soil. Sinkholes can be a serious problem in areas where clay and sand lie above the limestone mix. The clay causes these sediments to be cohesive. These areas are not very permeable to water and, thus, much more vulnerable to sinkholes.

Sinkholes can form abruptly after extreme rains common to the area. Hurricanes and tropical storms produce a large amount of water with extreme weight on the surface, which can cause a collapse of a cavity of limestone that has become thin due to the acidic erosion underneath. These can open violently and suddenly, swallowing up homes, cars and even people. Homeowners in Florida live in fear of sinkholes, as well they should.

There are several ancient sinkholes around the state. These have settled and are now state parks. Usually they house beautiful waterfalls, as they are well below sea level and the waters return down into Florida's aquifer. Most of these parks have scenic views of the sinkholes from a safe distance. There is one that leads you right down into the pit itself, and the legends surrounding it are as ancient as the hole itself.

The Devil's Millhopper State Park lies in the city of Gainesville, Florida. At one point, it was even part of the University of Florida as a place for students to study geology. Sadly, it was mostly used as a place to party,

and erosion was ruining the already fragile ecosystem of the area of the sinkhole. In 1974, the state purchased the lands of the park and turned it into a preserve. To help stop the erosion problem, stairs were built to the bottom of the pit so that you could still go down and see the mini rain forest environment that had developed within the pit without causing further damage to the ecology that now exists there.

Plummeting down 120 feet into the earth, Devil's Millhopper got its name for its shape, which resembles a grain hopper that the early settlers of the area were very used to. The muddy pool at the bottom was fed by no fewer than twelve streams from the surface. The pool itself was littered with bones of animals and even fossils. These unusual bones led the early settlers to determine that this was the entrance to hell and the bones must be those of demons. It might have even been the entrance to the River Styx of legend, according to some.

From the bottom, there is a canopy of shade trees around the rim, which keeps the temperature in the pit remarkably cooler than that above. This has created the mini rain forest–like damp green environment so different

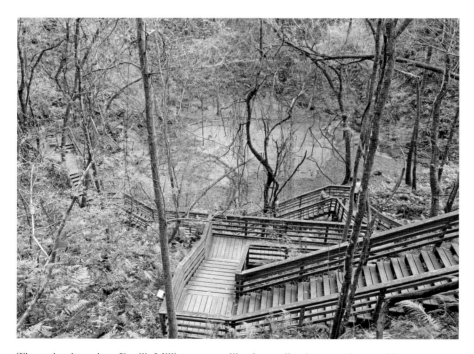

The stairs down into Devil's Millhopper are like descending into another world.

The basin at the bottom of the sinkhole contains a marsh that collects animal bones and fossilized remains.

from the sandy brushlands above. It is a unique location by any stretch of the imagination.

The legend of the Millhopper goes back even further than the early European settlers. There is a tale posted at the Devil's Millhopper station that details the great Timucuan chief named Potano and his daughter Sicuri. Though many other tribes had offered their best for the hand of Sicuri, Potano had refused them all, as none were deemed worthy of her.

There was another who sought her hand as well: the ancient demon Hiti. Once a great warrior whose pride had offended the gods themselves, he was cursed to walk the earth alone for eternity, forever denied the rest of the Happy Hunting Grounds. He vowed revenge upon the Timucua people and decided to steal the prize daughter away from the great chief as his ultimate revenge.

The demon snuck into their camp and used sorcery to make them all sleep deeply. He disguised himself as an old woman and woke Sicuri. Using the deception of a dying grandson, the demon convinced Sicuri to come with her. Potano awoke to find a bracelet of human teeth that he knew was the sorcery of Hiti. Realizing his daughter was missing and taken by the demon hated by his people, he summoned warriors from all the neighboring tribes to hunt the demon and free his daughter.

As dawn arose, Sicuri realized the deception but was trapped by the demon. Hiti also knew that Potano would send warriors, so he summoned

a great alligator to stop the warriors that would be following after him. The men carved a giant oar into a spear and did battle with the alligator. Potano himself helped spear the beast.

They chased the demon farther, and Hiti knew he was trapped. The demon then caused the very earth to shake and a deep pit to form around the warriors. As they were swallowed up and battered and broken by the fall, Potano lost all hope of seeing his daughter. He also knew that the tribes would never recover from the loss of so many warriors. Hiti appeared and began turning the warriors into stone. Potano was helpless.

Sicuri then escaped from her bonds and found one of the Timucuan atlatl, a spear of her people. She threw the spear right into the heart of the demon, who fell to the bottom of the pit, turning to stone himself. Chief Potano managed to climb out of the pit, and there he and his daughter wept, for they had been saved, but their people would need them more than ever. The legend is that it is their tears that flow into the pit to this day.

More recent tales from the 1880s describe a black pioneer family on their way to the free city on Amelia Island at the Kingsley Plantation whose wagon of cotton was destroyed when the ground opened up beneath them. The hole swallowed up an acre of pine trees. This story was repeated by preachers of the area as Satan himself had risen to swallow up sinners and the land they lived on. Many preachers took the story and used it often in the area, cementing the name of the legendary place.

No one is really sure exactly how old the pit is, as it seems to be two sinkholes on top of each other, one about a thousand years old and another possibly tens of thousands of years old. All we know is it is a beautiful place to visit and to explore a unique place of legend.

TOAD INVASION

Longwood

*I*n late May 1982, just before the long Memorial Day weekend was going to be celebrated by the town's chamber of commerce and historical society, the town of Longwood, Florida, was hit with a plague right out of the book of Exodus in the Bible. The *New York Times* described it in article from May 27: "An invasion of tiny, bug-eyed green toads has descended on this central Florida town."

The article went on to quote a Longwood resident of the time named Jesse Michael, who said "a three-inch wall of toads just fell in" as he opened his patio door. He continued, "You couldn't sweep them out fast enough." Though toads are as common in Florida as our gecko lizards, to be in such numbers is quite unusual.

There seemed to be no historical precedent, and the story made international news. Local scholars assumed it was due to the large rains that had occurred in February of that year. With so much water to breed in, the toads had propagated to the huge numbers the city was now enduring. Usually the bulk of each population boom is eaten by predators, but with recent high winds, the birds weren't in the area enough to feast on this bountiful harvest of amphibians.

The chamber of commerce noted that they had always had toads from the nearby lakes and swamps, but this time the numbers were hundreds of times greater than any they had ever seen. Some residents complained of being attacked by the pests when leaving doors open. Others complained of having to wear ear plugs to bed to block out the sound of the incessant croaking.

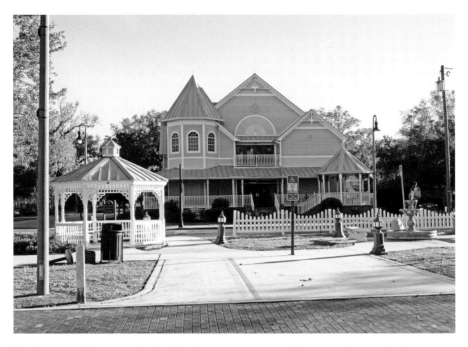

The Longwood Community Building hosts numerous weddings, meetings and other events, even when covered in thousands of toads.

One man had a different lament. He told the local newspaper that he mostly felt bad for the slaughter of thousands of toads as he mowed his lawn to avoid being fined for a code violation issued to him days before the invasion. He said thousands upon thousands of toads were now mulching his yard.

The invasion had little time for study, as it ended nearly as soon as it began on May 29. Seemingly without reason, the toads vanished back into the trees and neighboring swamps. Though reports of the birds finally arriving and feasting on the numerous dead toads lasted for a few more days, things finally returned to normal in the sleepy Central Florida town of Longwood by Memorial Day.

THE DEVIL'S CHAIR

Cassadaga

*J*ust off I-4 almost an equal distance between Daytona Beach and Sanford, Florida, sits an exit for the city of Lake Helen and Stetson University in nearby DeLand. However, there is a small sign just in front of the exit that looks like it was almost posted as an afterthought, and it simply says "Cassadaga." After a few twists and turns, some backtracking and crossing back over the interstate on a lonesome bridge, you will find the fabled spiritualist camp.

In 1874, George Colby, a noted medium in New York State, left for Florida at the behest of his spirit guide, an Indian shaman named Seneca. Colby was very ill with tuberculosis and was told not to do any extensive traveling. He ignored his doctor's wishes and listened to his guide. He left his home as he was shepherded to a marshy area in Florida with "unique hills" by this spirit. After traipsing through the swamps and exploring much of the Florida wilderness, he discovered the land of his visions. Colby decided to abandon his socialite life in New York to settle in this spiritually charged area. It was there he homesteaded and supposedly found a fountain on the lands that cured his TB. In 1875, he gave thirty-five acres of land to the Cassadaga Spiritualist Camp Meeting Association.

It was there that a grand hotel was built, and the area became a mecca for spiritualists and those interested in the paranormal. Today, Cassadaga hosts spiritualists from all over. Frequently referred to as the "Psychic Capital of the World," the township loves to boast that it has more psychics and mediums per capita than any city on earth. The entire area around the city is

The sign for the Andrew Jackson Davis Educational Center and Bookstore at Cassadaga.

a paranormal hot spot, with nightly ghost tours. Mediums, psychics, healers, palmists, oracles, clairvoyants, aura readers, past life experts, mind readers and augurs come here to lecture, teach classes, commune and enjoy the camaraderie of like-minded individuals.

The town also loves to point out, "There is no cemetery in Cassadaga." The point is stated on the FAQ on its website. It is stated on the sign at the local bookstore run by the Cassadaga Spiritualist Camp Meeting Association to this very day. It is also frequently stated by the staff of the hotel and nearly every local resident.

However, George Colby himself is buried here. Many people are buried here.

There is a cemetery. It just isn't exactly in Cassadaga. The cemetery is between Cassadaga and the nearby town of Lake Helen, and it is creatively named the Cassadaga–Lake Helen Cemetery. The graveyard stretches between two hills, with a small road through a valley in the middle. It is sparsely shaded, with moss-laden willows and a few cypress trees. The cemetery has graves from the late 1800s to the present and remains active today.

So, what makes something stand out in a whispered-about graveyard on the border of the largest spiritual commune in the southeastern United States? The devil himself, of course.

Cassadaga officials explicitly state on the city website that they do believe in God, a divine spirit or, as the spiritualists usually refer to it, "The Great Intelligence." It is a spiritual force that governs all things by natural law. The website also states that they believe in heaven and hell as alternate states of being and that they can even be experienced before death. It is also stated on the site that there is no devil, and everyone is responsible for their own actions. Their theology does not allow for anything to be a sin. With no sin, there can be no fall from grace.

With that in mind, the area tries to promote spiritualism and the paranormal with nightly ghost tours, séances and numerous mediums hosting readings at all hours either in the hotel or in the nearby gift shops. However, the town tries to distance itself from the darker side of the spirit world. The town is excited to host tourists and travelers interested in their community, but they really hate people looking for occultism, demonology or worse. That may be why they deny their town has a cemetery. Because the cemetery is rumored to be haunted by the devil.

As you walk through the cemetery, you will find among the tombstones two late nineteenth-century brick "mourning chairs." These were common at the time and frequently the source of many local legends all over the world. One of the chairs situated here is no exception. According to legend, one of the chairs here was built by the devil.

The unassuming brick chair has several legends attached to it. One states that if you sit in the chair at midnight on the night of a full moon, the devil will appear and grant you one wish for the price of your soul. Another local legend is that if you offer the devil a can of beer at the chair, it will be empty the following morning but still be sealed. Your wish will be answered, but for the small price of a beer instead of your soul. Still another legend states that no matter how hot the Florida sun, when you sit on the chair, it will be cool to the touch.

Sadly, it is not possible to test most of these legends, as the cemetery is strictly off limits after dusk. This area is frequently patrolled by volunteers from the local communities on nights of the full moon, Halloween and every Friday the thirteenth. The chair itself has sadly been vandalized with satanic carvings and numerous chips as people have defaced it and its surrounding wall. You can visit the graveyard during daylight hours and test the theory that the stones are cool to the touch no matter how hot the Florida sun might be. As expected, when we tested it was slightly cooler, as it is made of brick and stone, but so are the other mourning chairs in the graveyard.

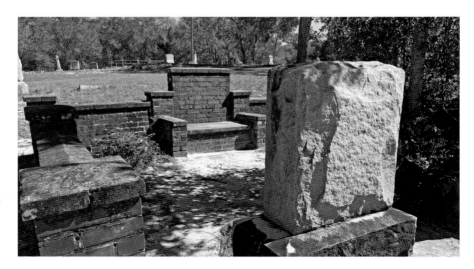

The infamous devil's chair in the Cassadaga–Lake Helen Cemetery.

There are groups of volunteers now to keep out those seeking to do mischief in the graveyard. There will certainly be no legend tripping here if the locals have anything to say about it. The local sheriff's office routinely gets called out to the Cassadaga–Lake Helen Cemetery and even sets up watch on dates of significance to help maintain the peaceful rest of those buried there. They like to point out that the hotel gladly hosts paranormal tours and ghost hunts and there is no need to bother any of the graves in the cemetery, and especially not to trespass and sit in a stone chair in a dark graveyard just to see if the devil will drink your beer.

In truth, the chair was most likely built by the family, as is the case with most mourning chairs of the period. It was simply a place for visitors to the grave to have a place to rest and reflect on their lost family member or loved one. The real mystery is how such a simple and mundane brick chair could become the focus of a legend involving the very devil himself.

There have been plenty of stories of people coming to the cemetery at odd hours and seeing bizarre goings-on. Thankfully, most of them are more of the drunk and disorderly being hauled off by the local police variety than of any more nefarious activities. However, in a town that celebrates the unusual and the strange, is it truly surprising to hear reports of unconventional activities in the local graveyard that the town refuses to admit even exists at all?

SKUNK APES

Ocala and Everglades City

*I*f Florida is known for one thing besides tourism and alligators, it has to be stories of the Skunk Ape, a large bipedal ape-like primate that stands over seven feet tall and stinks of death and decay. Though sightings of this infamous monster seem to come from every stretch of wilderness and swampland in the state, the bulk of the sightings come from the Everglades National Park. The Everglades Skunk Ape seems a peaceful creature.

However, there is one group of Skunk Apes that has been reported to be very aggressive. The splinter species seems so much more aggressive than those in the Everglades that researchers have referred to it as the Swamp Ape, not the Skunk Ape, though they are very similar. These reported creatures have even been known to attack individuals. The sightings are common throughout the otherwise peaceful Ocala National Forest. The worst of these attacks occurred near the ghost town called Kerr City.

The Ocala National Forest is the second largest nationally protected forest in Florida. The national park is so large that it covers over six hundred square miles of Central Florida. It is located three miles east of Ocala and sixteen miles southeast of Gainesville and stretches nearly all the way to Ormond Beach. Established in 1908, it is the oldest national forest east of the Mississippi River and the southernmost national forest in the continental United States. It is known mostly for the forest's diverse population of animals, including black bears, Florida black panthers and alligators. With no shortage of large predators and plenty of scrub game, it is not much of a stretch to believe another population of a large Bigfoot-like creature could live there.

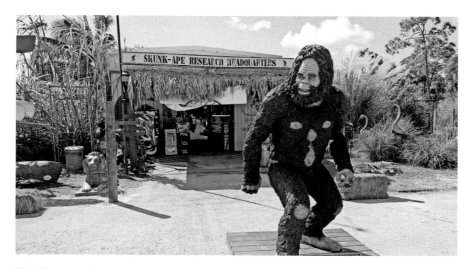

The Skunk Ape Research Center in Everglades City.

One of the most famous sightings of the Central Florida branch of this cryptid was a tale of three Boy Scouts camping in the forest in the late 1950s. They reported to the Silver Springs Ranger Station that their campsite had been attacked and destroyed by a "large smelly ape-man." Though initially dismissed as boys telling tall tales, upon inspection of the camp the rangers reported unusually large prints in the mud around the camp that weren't consistent with bear tracks. It prompted one of the first "Bigfoot hunts" of the modern age, of which there are numerous news stories. While nothing was ever found, it was widely reported and began Florida's reputation as a southern Bigfoot habitat.

Another famous encounter with the Ocala Swamp Ape came from a man driving along Route 40 through the forest late one night. He pulled over to rest for fear of falling asleep at the wheel on one of the numerous dirt roads that tend to wander to old hunting trails. He bedded down in the back of his pickup truck and quickly fell asleep. He claims to have been awoken as something very large grabbed him and dragged him out of his truck bed. His story included the classic large hairy beast with extremely long hair obscuring its face. He also described the classic "rotten cabbage smell" of the Skunk Ape. He reported the incident because he kicked the creature in defense and was initially afraid he'd hurt a homeless man or a hunter in a ghillie suit. It was only later, after driving away, that he remembered seeing how large the creature was in

CHILLING TALES FROM THE PANHANDLE TO THE KEYS

his rear-view mirror and hearing stories of the swamp monster and put two and two together. This is when most researchers realized that this was a much more aggressive beast or tribe of beasts in this area rather than the almost peaceful and much shyer Skunk Apes of the Everglades much farther south.

There is an abandoned town in the forest known as Kerr City. Kerr City lies between the St. Johns and Ocklawaha Rivers. Named after the surveyor who documented it in 1835, the area around Lake Kerr was originally inhabited by Seminole Indians. The Indians talked of the swamp beast that helped defend the area from threats to the peacefulness of the forest. The area was settled by a farmer from the Carolinas named Williamson. He owned a large cotton plantation until the Civil War after the natives had fled the area during the Seminole War. During the Reconstruction period, the plantation was converted to a citrus farm, and new settlers from the North began to homestead in the area. Sometime around 1884, Kerr City was formally deeded as the second city in Marion County, just behind Ocala.

The town was a bit of a boomtown in the 1860s, as the old stagecoach road ran through it for passengers from Palatka to the early days of Tampa because it was a natural stopping point after crossing the St. Johns River. The town housed a post office, church, sawmill, school and even a hotel. Many homes were built, and crops were planted all along the lake. Reports of bears were common in the area, as were tales of strange beasts that worked with the Indians to attack unwary travelers.

In 1894, just a decade after the town was officially platted, came one of the most devastating winters to hit Central Florida. It nearly destroyed all the citrus farms in the area. When the winter of 1895 came with a similarly terrible freeze, the final nail in the coffin of Kerr City was driven home. Farmers and their families left to find either work or other lands to homestead. The stagecoach also stopped, as the locomotive was now taking its place as the top mode of mass transportation. The school and pharmacy quickly closed, with the church soon thereafter. The town was a ghost town by 1905, though the post office remained open until 1941.

In 1907, the Kerr House Hotel that had been built in 1884 was burned to the ground. The town had already been mostly abandoned, but a preacher had brought his "flock" to Kerr City, and they moved into the hotel, which had been vacant for years. The legend states that one day they were attacked by "Hairy Earth Spirits" that were like "savage men." The preacher was so scared of these demonic forces that he fled the hotel and ordered it burned to the ground and the area sown with salt, as it was a place of evil. One

local story persists that the preacher had merely skipped town with all of his parishioners' possessions.

In 1905, one of the town's original families began to buy up all the surrounding properties that lay abandoned. Lillian Swan and her husband, George Smiley, suddenly owned most of the town. By 1955, their son Fletcher owned the rest of the town. Still in the family after all these years, the entire property is maintained by Fletcher's grandson Arthur Brennan at the time of this writing.

This ghost town allowed visitors up until late 2014, and many people rented some of the historically restored buildings. One such family reported being roused from their slumber one night when their car alarm went off. Upon looking out a window, they saw a strange seven-foot-tall hairy animal beating on their car and throwing rocks at the parked vehicle, presumably to quiet it. Eventually, the creature ran off into the woods. Although police were involved and freely discuss the incident, it was never reported, as no charges were filed. Kerr City is now fenced off, but you can still walk to the

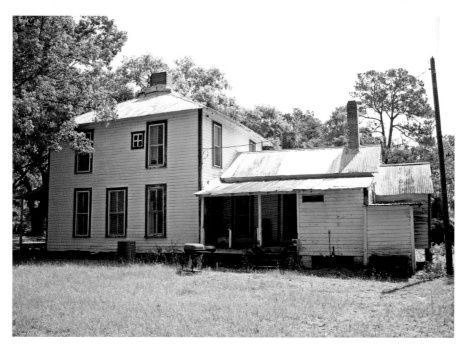

The house rented by boarders and then attacked by a Skunk Ape in the Kerr City ghost town.

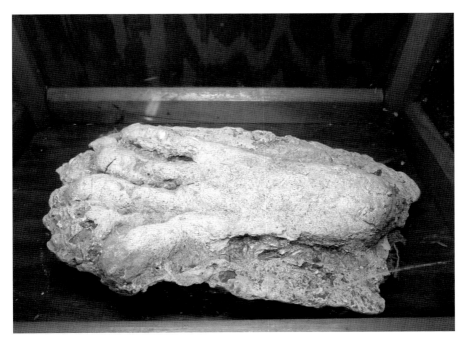

A plaster cast of the four-toed giant footprint on display at the Skunk Ape Research Center.

perimeter of the town. Residents of the area will gladly tell you stories of the Swamp Ape. It is a shame the city itself is now only on private property, as some of the historic buildings are in the National Registry of Historic Places, including the oldest gas station in Florida.

Swamp Ape sightings are still reported in the area quite frequently. There are websites that track the movements of the sightings. There are groups of hunters that will guide you through the forest near Lake Kerr in search of Swamp Apes. They will warn you to be careful, as the creatures here are not nearly as peaceful as their cousins farther south. These Swamp Apes are out for blood.

It should be noted that there are sightings of the Skunk Ape all over the state, including such famous ones as the Bardin Booger and those near the Skunk Ape Headquarters in Everglades City. Those creatures seem to be more placid and flee from humans. In the 1970s, there were attempts to pass a law protecting the creatures, but it was shot down as unnecessary. The fact that the law even was suggested due to so many eyewitness accounts is substantial in its own way.

 With no hard evidence other than some plaster casts of large footprints, dubious hair samples that so far have proven to be inconclusive and a bevy of hoaxed photographs, it is impossible to prove that this creature is real. And with so many reported sightings from all over the state that all have such similar descriptions, it is also impossible to dismiss these reports completely. Unusual wildlife tends to find new homes in Florida quite readily. Could it be that Bigfoot has found a home here deep in the wilds of Florida?

Spook Hill

Lake Wales

*T*here is a hill in the town of Lake Wales that some say is haunted. Others say a strange meteorite plowed into the earth and formed the highest point in Florida that the natives called Iron Mountain, and its strange properties affect everything in the area. One variant of the legend of this hill is so prevalent that it is even posted on a large sign at its base by the city that houses it to make sure it is never forgotten.

The story speaks of Chief Cufcowellax, who split his people from the Cherokee Nation and became one of the first Seminole tribes. He settled at a lake near Iron Mountain that is now Lake Wales. The land was bountiful, and the people enjoyed much prosperity for many years.

A great alligator began to raid the villages under the chief's protection along the banks of the river. The beast was said to be as long as some of the oaks that dotted the shoreline. Cufcowellax knew this to be no normal gator but an evil spirit sent to plague his people. He knew to respect animals and only kill for food, but this was no ordinary alligator or even simply a great beast; it had to be destroyed for the survival of his people.

Spook Hill is where the chief and giant gator had their final battle. The shaman of the tribe placed the chief under the direct protection of the Great Spirit and sent him to defeat the great evil spirit that had been haunting his tribe. The battle began, and the chief called upon the forces of nature itself to help defeat the giant beast that was nearly twenty feet long. The two wrestled, locked into a death grip and rolled into the nearby lake. When blood poured forth into the water, the people began to fear the worst. Then

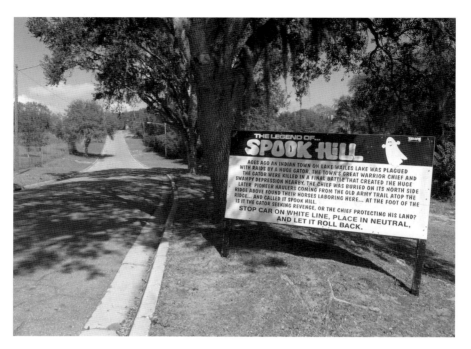

The world-famous Spook Hill with a sign erected by the City of Lake Wales explaining how to experience the phenomena and a brief synopsis of the legend behind it.

Chief Cufcowellax breached the surface of the lake. The celebration began as the beast was slain. The tribe then noticed a new and smaller lake had formed near where the battle had begun. This was where the chief had called down mighty winds and rains to slay the beast.

The smaller Lake Ticoa is still here and sits at the base of Spook Hill. The tale was almost lost as the Indians moved on, but when early American pioneers to the area began to notice unusual things in the area, the legend returned in force.

The story goes that early riders would realize their horses were struggling going downhill after coming off Spook Hill. Circus workers would notice that the donkeys that pulled their wagons would struggle around the lowlands of the hill but had no issues with the uphill areas nearby. The area's reputation was beginning, and the legends of the great battle of Chief Cufcowellax and the beast were once again circulated.

As transportation in the area changed into dirt roads and cars, the story took a weirder twist. One story states that a local black fisherman and well-known merchant parked his car at the foot of the hill in the 1920s. He went

The sign for Spook Hill Elementary School, with Casper the Friendly Ghost as the school's mascot.

to go fishing in the nearby Lake Ticoa. He was terrified to see the truck moving backward uphill on its own. He claimed that "spooks" were messing with his car and vowed never to return to that haunted hill. The name stuck.

Reports of paranormal activity in the area began to spread. Many believe that when the chief called upon the forces of nature in his battle, it changed the area in an unorthodox manner. Watches, radios and other devices would malfunction near the hill. Nearby Bok Tower, which stands on the legendary Iron Mountain, lies less than two miles from here and has its own unusual tales discussed in the next chapter.

A sign was erected by city officials of Lake Wales that states the following:

> *Many years ago an Indian village on Lake Wales was plagued by raids of a huge gator. The Chief, a great warrior, killed the gator in a battle that created a small lake. The chief was buried on the north side. Pioneer mail riders first discovered their horses laboring down hill, thus naming it "Spook Hill." When the road was paved, cars coasted up hill. Is this the gator seeking revenge, or the chief still trying to protect his land?*

Some years later, an elementary school was built next to the hill. It was named, fittingly, Spook Hill Elementary. The school chose Casper the Friendly Ghost as its mascot. While we were unable to determine if further paranormal activity has been reported at the school, it is interesting to watch children chase balls uphill on the school's playground when readying your car to experience the phenomenon of Spook Hill.

Now, visitors come from all over the state to park their cars at the base of the hill where the sign instructs them to do so. They put their car in neutral and miraculously begin to roll uphill. Many are happy to point out it is merely an optical illusion, and with a level one can see that what looks like up is actually down. Others state the strange meteor buried deep under the hill causes a gravitational well that pulls you up. There are even reports of time slowing down here and second hands moving slower on watches.

If nearby scenic Bok Tower Gardens, less than two miles away, doesn't draw your attention, then maybe a city that embraces the legend of a giant alligator pulling you into a small lake can give you a thrill. It's one of the first free roadside attractions in the state, and it still draws a crowd today.

GNOMES OF BOK TOWER

Lake Wales

Once again, we are drawn to the mysterious location called Iron Mountain. It is the highest point on the Florida peninsula at 298 feet above sea level. While not a dizzying height by any standard, in a state where the average height is 25 feet above sea level, it is quite impressive. Some legends state that it was created by a mysterious meteorite from space millions of years ago. The native tribes of the area knew it to be a sacred place and held it in high regard.

Eduard Willem Gerard Cesar Hidde Bok was born in the Netherlands in 1863. He immigrated to America at the age of six. A poor boy with no skills in English, he struggled on the streets to find coal for his family in Brooklyn while trying to find work to support his family. As he grew into a young man, he eventually became a highly successful publisher, a Pulitzer Prize–winning author and a respected champion of human rights and environmentalism.

As publisher of the *Ladies' Home Journal*, he launched crusade after crusade against indignities he saw. He helped coin the phrase "living room" to get people to actually spend time in their parlors, which helped transform the modern family home. His autobiography in 1920, *The Americanization of Edward Bok: The Autobiography of a Dutch Boy Fifty Years Later*, was so well received that it won the Pulitzer for best autobiography in 1921.

As Bok visited from his Pennsylvania home to the winter retreat he had made for his family near Lake Wales, Florida, he became fascinated by the

views from nearby Iron Mountain. One sunset in particular awed him so much that he wrote that it would "touch the soul with its beauty and quiet." He decided then and there to build a bird sanctuary.

He purchased a large piece of land on the mountain and began to transform it into a lush garden. He garnered the services of Frederick Law Olmsted Jr., a famous landscape architect, and they began to change the sandhill of Iron Mountain into a spot of further beauty. Nearly a year was spent simply digging trenches and laying water pipes for irrigation from nearby Lake Wales. He then ordered black soil by the thousands of tons and had it shipped to the gardens.

The planting began for subtropical plants and trees, which still provide shade for visitors today. He then began to build a reflecting pool to attract wildlife. This was a great success, as it is now home to over 126 species of migratory birds throughout the calendar year.

At the heart of what Bok was calling the Mountain Lake Sanctuary, he built a beautiful sixty-bell carillon tower. Dubbing it the Singing Tower, he presented the gardens to the American people as a gift on February 1, 1929, as his enduring appreciation for the opportunities that only this country could have afforded him.

The tower alone with its pink marble blended with Florida coquina stone is a marvel to behold and well worth the visit. The beautiful carillon, now with seventy-one bells, rings out beautiful music to guests and tourists who go for picnics and just to marvel at the wonderful gardens still on display today.

The area around the mountain still has legends and tales. Nearby Spook Hill is of note and discussed in the previous chapter. While only two miles away, it is not truly in sight of the tower. There is one odd tale that we have to tell that lies just outside the gardens.

In 1955, Edwina Rankin was a young girl on her aunt's orange grove in Lake Wales. It was well within sight of the Singing Tower, and she recalled hearing its bells ring out hymns and pleasant tunes at all hours of the day. She would help her aunt and their laborers work the trees; it was truly back-breaking work once harvest time began.

That year stands out with her strongly, as they noticed an unusually large number of oranges seeming to go missing from the trees. While rats and other pests could account for some of the missing fruit, there was a lingering doubt that a neighboring family might be stealing the fruit, or even passing circus folk, whom she referred to as her family's fear of gypsies. She was only seven at the time, so she paid it no mind,

An early postcard showcasing "The Singing Tower" of Bok Gardens. *Courtesy of the St. Petersburg Museum of History.*

The orange grove today, with Bok Tower seen in the distance.

Her aunt paid an exterminator to go and put traps among the orange trees to see if there were just too many rats in the area or maybe some other troublesome pest. What they caught was something she would never forget.

Edwina tells of the capture of a small naked man no larger than a foot tall. The man was screaming in a foreign tongue and covered in short hair. They knew he was no child, as he had a full face of hair. The aunt told Edwina it must be a Lilliputian from *Gulliver's Travels*. Fearing they had injured some circus performer or even one of Ripley's Believe It or Not exhibits that had come from St. Augustine, they let the man go—particularly since they couldn't understand a thing the little man said.

More crops went missing over the next few weeks, and they felt it certainly couldn't be the work of the strange intruder they had captured weeks earlier, so more traps were again placed out. Within days, the little man had been caught again.

This time, the authorities were called, and not knowing what to do with the man, the family placed him in an orange crate with holes in it. The police arrived and were confused by this diminutive man as well. They took him into custody and drove away in their police car.

"The little man was so hairy and small that they put him in one of the orange crates to carry him off." *Illustration by Kari Schultz, 2017.*

Edwina says the next night was horrific. Dozens of the little men swarmed their house, screaming and throwing stones at the home. Her aunt was convinced that they were demanding their lost brother back, so she phoned the police again. They brought the captured man back and let him loose. He and the others vanished quickly into the grove.

Unsure what to do, the police simply left, and Edwina's family looked for alternative solutions to their problem. One of the Irish farmhands said that the little people appeared to be similar to the gnomes or red hats of legend from his home country. He told them the only way to be rid of them was to get a sacred stone from Ireland shipped here and blessed by a priest. This would give the gnomes something to understand that this place was sacred and to not steal fruit from it. The aunt had the farmhand send word back to Ireland to make the arrangements for a sacred stone to be acquired.

She wasn't allowed to watch the ceremony, but Edwina swears to this day that after the rock was put in place, no more little men ever stole their fruit. Edwina visited the farm for many years and lived in nearby Lake Wales until her passing. The family sold the grove to a large farming firm sometime later.

The area where the stone supposedly still lies is currently where the new owners of the farm keep their beehives to help pollinate the orange grove. So, it is best not to try to visit today. However, if you do see any little men stealing your fruit, it might be a good idea to get on the phone to Ireland to get a big rock.

THE BRADLEY MASSACRE

Brooksville

As stated on the historical marker placed in Pasco County, Florida, by the Pasco History Preservation Committee and the Pasco Board of County Commissioners in 1979 near the intersection of Bellamy Brothers Road and Saint Joe Road, a terrible event occurred close to that very spot in 1856. The marker reads as follows:

> *THE BRADLEY MASSACRE.*
> *NEAR THIS SPOT ON MAY 14, 1856, A SEMINOLE WAR PARTY ATTACKED THE HOME OF AN EARLY SETTLER CAPT. ROBERT DUKE BRADLEY OF THE FLORIDA FOOT VOLUNTEERS. TWO OF THE BRADLEY CHILDREN WERE KILLED BEFORE THE INDIANS WITHDREW. THIS WAS THE LAST SUCH ATTACK ON A SETTLER'S HOMESTEAD EAST OF THE MISSISSIPPI.*

The attack memorialized on the monument occurred during the period known as the Third Seminole War, in what was then new land opened to settlement. After the end of the First Seminole War in 1837, many of the Native Americans within the area were relocated to reservations by the U.S. government. They were taken to what was called the Indian Territory, now known as Oklahoma. Many natives refused to go. Most fled into either the Everglades and the southern part of the Florida peninsula. The government had opened all territory north of the Everglades to settlement. Most of the region was being settled by soldiers who had fought in the area and had come to admire Florida for its climate and natural beauty during their stay.

This monument marks the Bradley Massacre, which occurred near this location.

Among the first settlers in this location, just south of the Withlacoochee River, was Major R.D. Bradley of the United States Army. He had fought all over Florida, primarily out of the fort located in Tallahassee, where he was stationed. One of his most famous acts included rescuing a boy captured by an Indian raid in a nearby town. He and his men tracked the raiders for several days and caught up to them at night. The story states that Major Bradley fought single-handedly with an Indian chief and managed to rescue the boy without harming any of the other natives. Only the recollections of his daughter, Mrs. O.A. Darby, who lived in Tampa, mentioned the incident in question in an article for the *Dade City Banner* on August 4, 1922.

Sometime in the early 1850s, a group of Seminole warriors decided to once again take up arms and head north to raid the settlers living in their former lands. Their faction was led by Chief Billy Bowlegs II. This plot is what came to be known in history as the Third Seminole War. By the end of this conflict, only a handful of the Seminoles remained alive, escaping into the Everglades. The peace that followed did not last for long, as these scorned warriors wanted revenge for their stolen territory.

At first, small raiding parties began burning the settlers' homes in what is now the Sarasota and Bradenton area. A short time later, they turned their attention farther north, into Hernando County, which at that time extended into what is now Pasco County. Several homes were destroyed, and a highly publicized murder of a local ferryboat operator, John Carney, took place in the fledgling settlements along Tampa Bay.

Then came the spring of 1856, when the group of raiders made their final run at a target much despised by many within the Seminole tribe, the man responsible for slaying their much beloved warrior chief, Tiger Tail. That man was Major R.D. Bradley, who was living within the settlement of Darby, just about fifteen miles south of Brooksville. The raiders passed several other easier targets on their journey to Darby, making it blatantly clear that the Bradley homestead was their destination for retribution.

The retired Major Bradley was in poor health, stricken with a pronounced hemorrhaging of the lungs, as per reports of the incident. He had settled near Tampa Bay so that he could see the attending surgeon at Fort Brook. His family had moved several times in recent years due to the fear of Indian attack. They had settled in Darby for communal protection. People in nearby settlements had recently seen some moccasin tracks in the surrounding area and had taken to gathering together for safety. Nearly every settler was armed after hearing the reports of the raids to the south. But after a few weeks of calm and no further reports of violence, a collective sense of relief washed over the area, and Darby returned to typical frontier life. Major Bradley was being visited by a cousin from the Carolinas named Mack Johnson. He was partially bedridden at this point due to his advanced illness; in Bradley's absence, his land was being managed by an overseer named Bowen.

On that fateful night in May 1856, the children of the Bradley family were playing between the two sections of their log cabin. Some of the children were headed to the cow pen, where Bowen was working. One of the younger sons, William, was on the porch, reading by candlelight as the sun set.

The chilling, familiar cry of a war whoop echoed forth from the woods as a party of fifteen Seminole warriors came riding in and immediately opened fire on the homestead. One of the daughters, Mary Jane Bradley, was shot in the shoulder. In agony, she staggered into her father's room but died as she opened the door. Her bleeding body fell onto the floor in front of her helpless father. In a panic, Mrs. Bradley ran outside to grab William from the front porch. He had been shot in the gut. She managed to carry him into the bedroom, getting him to safety. Despite his grievous injury, William grabbed his gun, handed it to one of his brothers and said, "Fight 'til you die." He then collapsed, succumbing to his wounds, and died on the spot. At this point, Major Bradley, still reeling from the sudden death of his daughter, had stepped into action as well, grabbing his gun and preparing to fight.

Stricken with fear, Mrs. Bradley raced throughout the settlement, trying to find her children and get them out of harm's way. Even as she ran from room to room, not so much as a single bullet hit her. In the midst of the insanity, she swore that she saw a white man leading the raiding party and giving orders.

The Indians advanced up to the steps of the settlement. There was a cry of "They're coming in!" from Mrs. Bradley as she witnessed their approach. The major managed to shoot one of the leaders through a crack in the

cabin walls, bringing their efforts to a halt. The attackers fell back but kept firing on the house from afar, doing minor damage at best. The Indians then grabbed sheets from a nearby clothesline and carried away their wounded as they fled. The sounds of gunfire had roused the neighbors, and help was quick to arrive. By morning, word had reached the nearby Fort Taylor, and soldiers were dispatched to locate the raiding party.

The Indian camp was found in Big Cypress Swamp, near the grave of their fallen comrade Tiger Tail. A book called *The Spoiled Child*, evidently stolen during a previous raid, was found on the grave. The soldiers pursued the raiders, undergoing several battles with them as they retreated south. Among these fights was one that occurred just north of Tampa Bay, near Fort Tillis. The Seminoles were finally overtaken as they neared Fort Meade and were either killed or captured.

This raid was the last time any homestead was attacked by Indians east of the Mississippi. The citizens of the area were very shaken by this ordeal and sent a letter to General Carter of Tampa, asking him to send troops to pacify the region. By 1858, thirty-five warriors, as well as eighty-five women and children of the Seminole tribe, including Chief Billy Bowlegs II, had been rounded up and deported from Egmont Key to the reservation in Oklahoma.

Following the tragic events of the raid, the Bradley family remained in the Darby settlement for several years. The story of Major Bradley, however, doesn't end there. Near the end of his days, one of Bradley's sons reported that he could hear his father talking to Tiger Tail and several other fallen Indians. They were haunting him. Bradley was telling the spirits that he acted out of vengeance for a young lieutenant who had been killed under his command years before. First Lieutenant Whitaker had been killed while out scouting, and Bradley had been the one to discover his corpse. His body had been hacked to pieces by the Indians. It was then that Bradley had vowed to kill an Indian for every piece that had been cut. It was his way of collecting a "counting coup" of his own. (A counting coup was a tradition of the Plains Indians in which a young brave would face a challenge or hardship to win prestige or honor.) He adopted this practice to justify his vengeance, and because of it, the spirits were angry.

On his deathbed in 1858, just as the last members of the Seminole tribe were being rounded up, Major Bradley was surrounded by his family as they awaited his end. According to the legend told by those present, a band of Seminole warriors materialized by his bedside and brought down axes into his chest. He lunged forward with a loud, gasping cough and died as

the warriors disappeared, vanishing as quickly as they had arrived. Had the warriors claimed a coup of their own?

So, when traveling through Pasco County, be sure to stop at the marker and pay your respects to both Major Bradley and the poor children killed while they defended their home, as well as the indigenous peoples of Florida who only sought to defend their homeland from invaders.

MERMAIDS

Weeki Wachee

*T*here is a town on the Gulf coast of Florida just an hour north of Tampa. The town is as quirky as its name, Weeki Wachee. The city has a population of around two dozen people. The current mayor is proud to state that she is a former mermaid from Weeki Wachee Springs, one of the oldest roadside attractions in Florida.

Weeki Wachee was named by the native Seminole Indians, calling it the equivalent of "Little River Spring." The spring here bubbles up over one hundred million gallons of fresh water from subterranean caves that have only recently been attempted to be mapped. No one has ever found how deep they truly go, but in 2007, the Karst Underwater Research Team was able to send divers down as the springs had dropped their output sufficiently to map the caves some. They found over two miles of caves in an average depth of over 250 feet with lukewarm water averaging around seventy-five degrees Fahrenheit. The maximum depth they could map was over four hundred fathoms. This makes Weeki Wachee the deepest naturally formed springs in the United States of America.

In 1946, a former World War II SEAL named Newton Perry was looking for a new site to start a potential business. He found the town of Weeki Wachee on then fledgling two-lane road U.S. 19 just north of Tampa Bay. The springs here were filled with refuse, including old automobiles and refrigerators. He began the process of cleaning them out and developed a method of pumping oxygen in a hose into the spring to allow for breathing under water without the need for a diving tank or external gear. Suddenly,

A postcard showing the mermaids of Weeki Wachee about to flag in a passing car. *Courtesy of the St. Petersburg Museum of History*.

3035 WEBB'S TALKING MERMAID SHOW

A postcard advertising the Webb City Mermaid show. *Courtesy of the St. Petersburg Museum of History*.

he realized it could look like people were thriving under water in these clear springs where you could see for hundreds of feet. He began to build a theater six feet under water and then began to seek out beautiful young women whom he could train to be his mermaids.

Mermaid legends are common throughout history, with many coming from the early days of exploration of the state by European settlers. The common theory is that sailors would confuse either dolphins or manatees for mermaids, which could explain many of the sightings of the legendary sea sirens of the oceans. One incident in particular was written of by Emily L. Bell of Fort Pierce in her memoirs about living in Florida in the late 1800s. Emily claimed that her family would travel to Jupiter Inlet, just north of Palm Beach, Florida, by boat. While walking along the coast one day, she heard something large rustling through the mangroves. Her husband went to investigate the noise, and they saw a strange sea creature with a human head that crawled off into the water after looking at them. When she reported the sighting, the locals told her the creature was sighted quite frequently. The local Indians would not kill it for fear of bad luck, as it was considered by them to be a nature spirit.

There are reports in 1927 that the creature was spotted again, involving soldiers from nearby Fort Pierce coming to investigate the creature. By the

A microphone wired to a speaker near this statue would call customers to Lorelee's Cove at Webb City. *Courtesy of the St. Petersburg Museum of History.*

time they mobilized, the creature had vanished back into the sea. More recent stories involve strange fish with human arms, legs or heads washing ashore shortly after storms as they struggle to get back into the water. Nearly every fisherman from the Keys to the northern beaches of the state has heard tales of mermaids and sea serpents with human heads.

Familiar with the legendary Fiji Mermaid on display at Ripley's Museum in St. Augustine and its popularity dating back even to the 1850s with P.T. Barnum, Newton Perry devised a way to bring proper mermaids to life. His new theater opened the Weeki Wachee Springs mermaid show to the public on October 13, 1947. In those early days, cars were not common on U.S. 19. Newton had the girls go out to the street in their one-piece swimsuits to beckon travelers in for a show when they would hear the engines of a passing car. Just like the sirens of legend, these pretty ladies would try to ensnare tourists with beauty. Once inside the theater, they would beguile them with underwater ballet shows. Sometimes they would reenact plays or tales, including their take on Hans Christian Andersen's classic tale *The Little Mermaid.*

In the 1950s, the shows had become world famous and were a popular destination for tourists from all over the world. The mermaids were treated

like royalty and given etiquette and ballet lessons. Celebrities would make a note of stopping there. Several movies were filmed at the springs due to their unusually clear water. In 1959, the American Broadcasting Company (ABC) purchased the park. The broadcasting company began to rebuild the theater and heavily promote it. The new theater was sunk another ten feet for a total of sixteen feet under water, and more attractions were built above ground. Elaborate props and stages were built in the springs, and further themed shows were introduced. Women from all over the world aspired to be Weeki Wachee Mermaids.

This was not the only mermaid show, however, on the Gulf coast of Florida at the time. A short distance away in downtown St. Petersburg, there was another entrepreneur cashing in on the mermaid phenomenon. In the late 1920s, during the Great Depression, many businesses were trying unusual promotions just to get people in the door. The "stack it high, sell it cheap and watch it fly" model that would later see the successful rise of Wal-Mart was still a new trend. In 1925, James Earl "Doc" Webb bought into a struggling pharmacy in St. Petersburg. He would grow that store into a tourist attraction unlike any other.

The formula of discounts and crazy carnival-like attractions, including chimpanzees, baseball-playing ducks, dancing chickens and two-cent breakfasts, worked like a charm. People flocked to this unique drugstore. While other businesses around him were failing, Webb began to buy them and expand his own. This led to his owning more than seventy businesses in the area that eventually spanned seven blocks from Second Avenue South all the way down to Fourth Avenue South and between Seventh Street and Tenth Street. Groceries, hardware, furniture, haircuts, clothing, dry cleaning and even an Arthur Murray dance studio on the roof of one of his buildings were all available in "Webb City, the World's Most Unusual Drug Store."

Webb City employed nearly 1,200 people and catered to nearly 60,000 customers a day at its apex. When business began to slow, Doc Webb would introduce something new. He remembered the legends of mermaids along the Gulf and decided he needed his own mermaid show. Initially, he installed a lone mannequin and dressed it like a mermaid. He installed a speaker and would have tellers use a microphone to call people into a small area Webb called Lorelee's Cove. Inside, an actress in a mermaid costume would tell stories and jokes on a makeshift lagoon stage. This attraction proved immensely popular and was a mainstay at the store even after so many other promotions had run their course and were abandoned. After a time, mermaids were hard to come by, so more mannequins were placed inside

The entrance to Weeki Wachee today.

Mermaid Point was a bait shop and tourist attraction of its own near the area that is now Shore Acres in St. Petersburg. The building is long gone, and the former location now is a block of condominiums. *Courtesy of the St. Petersburg Museum of History.*

Lorelee's Cove. More speakers were installed, and the mannequins would call to children by name, as provided by parents eager to give their children a thrill while shopping. The mermaid mannequins had replaced the need for actresses. They would tell the customers stories and entertain them for a short while for the cost of a quarter.

Eventually, even with such mainstays and history, Webb City began to fall on hard times. The area around it was falling into urban decay. Webb could only do so much. Webb City closed in 1979 forever. A local St. Petersburg restaurant claims to have one of the original Webb City mermaid mannequins in its lobby to this day.

Weeki Wachee was nearly suffering the same fate in the mid-'80s, as the attraction had seen better days. Nearby Orlando and the beaches themselves were enough for tourists, and there was no longer a need for mermaids to entertain children in the backseat to keep them from meltdowns. Thankfully, the park received a shot in the arm when Disney created the movie hit *The Little Mermaid* in 1989. Suddenly, the park was popular again.

In 2008, the park was purchased by the State of Florida Water Management Division and turned into an official State Park of Florida. The mermaid show is still run by a private company that leases it from the state. The park is still thriving, with the neighboring waterpark doing brisk business. The mermaids are still stars and treated like queens at the park.

With the dawn of CGI and the burgeoning film industry in Florida, numerous bodies of mer-creatures and even videos now flood online streaming sites with reports of "real mermaids" caught on tape. The Discovery Channel has even run documentaries attempting to discern whether these sightings and evidence are of real creatures. All we know is the legends live on for centuries here. The oceans hold many secrets. Plus, there will always be people and places cashing in on those myths.

The Trestle Bridge Spider Monster

Tampa

Trains have always been an important part of American history, and this was no different in Florida. The Atlantic Coast Line (ACL) and the Seaboard Air Line (SAL) mostly controlled the early trains to Florida. A small rail line extended from Fernandina to Cedar Key in the early days of railroads in the mid-1850s. It would be more than twenty years after the Civil War before rail service would extend south from northern Florida.

During the Civil War, a railroad branch was constructed between Live Oak, Florida, and Dupont, Georgia, to move Confederate soldiers and supplies north. Rails from the old Florida Railroad were taken up and used to build the Live Oak line. Toward the end of the war, Confederate soldiers began to damage the lines intentionally in order to slow the advance of Union troops. Union forces around that time also sabotaged railroads and infrastructures around Jacksonville. Less than 40 percent of the 355-mile line from Fernandina to Cedar Key remained by the end of the war.

In 1886, Edward Reed of the Peninsular Railroad system began to buy and merge several pre–Civil War northern railroad companies into a single system. He then began to expand them southward. His chief rival was Henry B. Plant and the Plant System Railroad. The Plant System grew from a short railroad extension in Georgia into a grand empire that would eventually win the race to run a line to the port of Tampa.

In April 1881, Sir Edward Reed and a European investment syndicate saw the potential for profit in the Florida railroad systems. Two former railroads, the Atlantic Gulf and the West India Transit, were sold at auction.

Reed and his investors purchased them and changed the name to the Florida Transit Railroad. This railway included the Fernandina to Cedar Key line and several other divisions. In January of that year, Reed had purchased the Tropical Florida Railroad with the intent to go all the way from Ocala to Tampa by the end of the following year. As of June 1882, they had only reached Wildwood, nearly ninety miles from where he wanted to be.

So in 1882, Reed continued his buying frenzy to spur development. He purchased the old Florida Central, the Jacksonville, the Pensacola and the Mobile Railroads; combined them; and renamed them the Florida Central and Western Railroad Company. In January 1883, he continued this merging by combining the Florida Transit, the Tropical Florida and the Peninsular Florida Railroads into the new Florida Transit and Peninsular Railroad Company. This was a previously unseen sequence of reorganization and rebranding in such a short space of time.

New investors were sought out, and in 1884, Hamilton Disston granted much of his land in Central Florida to the Florida Central and Western Railroad. The Florida Transit and Peninsular Railroad were all consolidated again, this time into the Florida Railway and Navigation Company. At this point, rails had been extended from Tavares via Leesburg all the way to Wildwood from Plant City. By 1886, further financial problems had slowed down progress to the south. Reed stepped aside instead of attempting another reorganization.

It wouldn't be until 1888 that W. Bayard Cutting would reorganize the Florida Railway and Navigation Company into the Florida Central and Peninsular Railroad and Tampa could finally be reached from Plant City. Unfortunately, that was six years after the Plant System had already gotten there.

Henry B. Plant and the Plant Investment Company (PICO) entered Florida in 1879 by purchasing Georgia's Atlantic and Gulf Railroad. The company received a charter to continue the East Florida Railroad line from the Georgia border to Jacksonville. They completed this in 1881, and it was known as the Waycross Short Line. Plant then managed to obtain the charter to extend the Plant Line from Live Oak to New Branford. He then purchased the Live Oak, Tampa and Charlotte Harbor Railroad's charter, which extended his line from New Branford to the ultimate goal of Tampa.

In 1881, a company called the Jacksonville, Tampa and Key West Railway had procured a charter to build a rail line along the St. Johns River from Jacksonville to Sanford. It also had licensed a charter to build an extension between Kissimmee and Tampa Bay. When it needed further funding to

finish the Sanford portion of the line, Henry Plant agreed to help finance as long as the company would give him the charter to Tampa Bay.

Not much of this line had been built before Plant realized that another company, the Florida Southern Railway, had already been charted to build a line along a very similar route. Plant began negotiations immediately with investors so that the routes could combine rather than compete. They came to an agreement in December 1883. Plant helped them reach from Gainesville to Charlotte Harbor in exchange for the assistance of Florida Southern to help him reach southwestern Florida.

Another New England syndicate of investors called the South Florida Railroad was building a line from Sanford to Orlando. They had reached Orlando via Longwood and Winter Park by December 1880. In March 1882, the line was extended to Kissimmee. Plant was eager to extend the South Florida Line toward Tampa Bay, so he purchased 60 percent of the South Florida Railroad, and with the urging of Hamilton Disston, he extended the line from Orlando to Kissimmee in 1882.

In 1884, Plant discovered that the South Florida charter to Tampa was due to expire at the end of January. He knew that he had to speed up the South Florida construction line to Tampa via Lakeland and Plant City at all costs. The line managed to open just days before the charter expiration. The race to Tampa was over.

The early days of railroads in Central Florida would lead to the dominance of the ACL and SAL lines for over fifty years. The freight business from Tampa Bay was the mainstay for profits, but passenger service had begun to boom also. Luxurious trains shuttled passengers to the cities of Clearwater, St. Petersburg and Tampa, with direct service to New York and other northeastern United States destinations. Even Chicago and the Midwest had direct lines to Jacksonville, with many continuing on to Tampa Bay.

The train boom peaked in the 1920s and eventually declined as air travel and the highway systems began to compete with the railroad system. In 1967, the passenger services all merged into the Seaboard Coast Line. Amtrak purchased it shortly after. Amtrak passenger service continues to this day to Tampa; however, direct rail to Pinellas County ended in 1984. It was replaced by connecting bus service. At the same time, the Seaboard Coast Line continued freight service to Tampa and eventually evolved into the CSX Transportation Company that still runs shipping to this day.

The cost of building the lines at such speeds through the Florida swamps and heat was high. Many railroad workers lost their lives to the rigors and

The infamous Nebraska Avenue Trestle Bridge just after a flood in Tampa in 1935. *Courtesy of Tampa–Hillsborough County Public Library System.*

dangers of the job. Most are forgotten by history. It's no wonder that there are so many ghost stories and legends abound about railroads, particularly those deep in the Florida wilds.

One legend stands quite literally head and shoulders above the others in Tampa Bay. A lone trestle bridge in Tampa, just off Nebraska Avenue, may be the home of a legendary figure that some say may have been the inspiration for the "Slender Man" Internet phenomenon.

According to students at nearby schools, this bridge was built at the cost of the life of at least one railway worker. The bridge spans the Hillsborough River, which rises quite high during the summer rains. Apparently, a particularly nasty storm flooded the bridge during construction, and the man lost his life, washed away in a torrent of mud and rain.

Somehow, the man's body became merged with a crab- or spider-like creature. The beast uses the man as its face to try to hide its spidery appearance. Similar to an anglerfish, the long-decayed and slender body

The spider-like creature comes out of the shadows on the old Nebraska Avenue Trestle Bridge. *Illustration by Kari Schultz, 2017.*

beckons for help from the bridge. Once close, the long, dark legs can be seen as they reach out along the bridge toward unsuspecting victims. A high number of suicides are attributed to this bridge. This may help mask the creature's success rate.

In some modern versions of the tale, the body the creature uses had been prepared for a funeral, and the coffin was lost on the bridge as the train crossed during a flood. This version is why some say the body is dressed in a dark suit with a long tie. It is this version also that states the creature behind it is more like a sea monster. Either tentacles or crab legs come out to catch its victims.

This is where the Slender Man connection to modern urban legends begins to come into the story. Slender Man is a modern myth created in an Internet Photoshop contest that took imaginations to new heights of terror. It helped spawn a whole subculture of myths dedicated to things like it. These are often referred to as "Creepypastas." The legends are named after the website where these stories are archived. These stories grow and are edited by Internet users in a similar vein to Wikipedia. It is not difficult to imagine someone from Tampa added the spider legs or tentacles of this legend into the online version of Slender Man, which already had an unusually tall, featureless man in a suit stalking children. The monster is not too different from the local legendary creature living at the trestle bridge.

The neighborhood near the bridge in Tampa is now an economically depressed area. It is often home to gangs, prostitution, drug deals and other criminal activity. Still, modern legend trippers test their bravery by seeing if they can walk out onto the bridge and not get grabbed by the creature. Some call it the Trestle Bridge Monster, the Boxcar Spider or the Shadow Man.

Haunted trestle bridges are common in modern folklore. Many have a history of suicide and rail accidents. People walking the rails get stuck on them, with nowhere to go but the waters below or face first into an oncoming train. All we know is that crossing any trestle bridge is dangerous and should not be attempted by anyone. Even if you aren't afraid of zombie-headed spider monsters, definitely do not try this one at home.

THE LADY IN WHITE
AT THE BOATYARD VILLAGE

Clearwater

At some point in the mid-1970s, a local aircraft collector decided to spend some money improving the area around the St. Petersburg/Clearwater Airport. Tourism was booming in the state thanks to Disney World and the famous Clearwater Beach, which was becoming the spring break mecca for high school and college kids. A fishing village on nearby Madeira Beach called John's Pass was doing booming business, so the collector, David Challichet, helped gain the funding to build a replica turn-of-the-century fishing village just a short distance from the airport.

Opening to much fanfare with unique shops and restaurants, the Boatyard Village was the home of dozens of businesses that tourists flocked to in the early to mid-1980s. The famous 94th Aero Squadron Restaurant opened here before moving to the other side of the airport and featured headsets where you could listen to the air tower controllers at the bar. The Itsy Bitsy Teenie Weenie Bikini Shop sold designer swimwear. On the drive in was a famous Spanish restaurant called Los Fantanas, which once even hosted a campaign rally for then vice president and presidential hopeful George H.W. Bush.

Now there is nothing there but memories and mangroves that have reclaimed this once festive fishing village. After numerous code violations and dwindling business, the village closed shop sometime in the mid-'90s, and the entire area was purchased by the airport to expand its coast guard services. The road that led there is now marked "NO TRESPASSING" with a very clear sign.

A photograph of the Boatyard Village Theater from a *St. Petersburg Times* staff photographer from January 16, 1987, when the theater reopened after a year and a half of being dark. *Courtesy of the St. Petersburg Museum of History.*

One location there that many visitors recall was the famous Boatyard Village Theater, which housed many local plays and productions. Near the end, the theater had been turned into a club in an effort to resurrect the area and even held festivals in 1989 and 1990, but it was too little too late for Boatyard Village.

In 1991, there was a great fire that engulfed the theater and several other businesses. It was the final nail in the coffin for the old village. The fire was blamed on faulty wiring, combined with the properties' many other signs of neglect. The buildings had been built to look old and decrepit, and now they actually were. As the '90s progressed, the last few restaurants closed, and the old shopping village eventually only housed telemarketers and other businesses seeking a cheap place to do business with low overhead.

By the year 2000, the place had been demolished and nothing was left standing. Even the historic Los Fantanas restaurant was closed, with no real traffic flow in its direction anymore. It was demolished shortly thereafter.

One resident still remains.

A *St. Petersburg Times* staff photo from May 17, 1991, showing firemen putting out the fire that would severely damage the theater and destroy the building next to it. *Courtesy of the St. Petersburg Museum of History.*

A ghostly "lady in white" was seen many times at the theater in its heyday. She wore a period-style costume of a white dress and would be seen in fleeting glimpses wandering around the theater. One actor spoke of seeing her on the stage pointing directly at him. He nearly fell off the stage in fear. Another lighting director at the theater told a tale of the lady in white standing on the middle of the stage as the curtain drew, and the crowd didn't realize she wasn't part of the play. When one of the actors screamed and ran, she vanished in front of an astonished matinee audience.

At one point, a haunted house attraction, hosted by local legendary TV horror host Dr. Paul Bearer and a lady calling herself Madame Guava, was opened in the Boatyard Village. They used the fictional local holiday of Guavaween to celebrate the opening. The lady in white was frequently discussed as being an unpaid extra.

When the fire nearly completely destroyed the theater in 1991, the sightings of the phantom in the white dress did not stop. Many said she now carried an umbrella or parasol and walked around the boardwalk in the pre-dawn hours. One former security guard told us that he would see

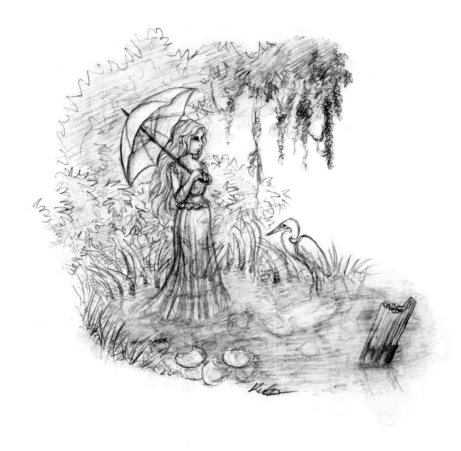

The lady in white strolls with her parasol through the mangroves that now grow where Boatyard Village once stood. *Illustration by Kari Schultz, 2017.*

her walk out to the water's edge and look up at the rising sun as she faded from sight.

After the complete destruction of the site and closing to the public in 2000, tales of the lady in white disappeared for a time. That was, until the sport of kayaking became a craze in the area. Boaters now report seeing her walking through the mangroves or even floating where the old boardwalk used to exist. There are sightings of her to this day by boaters near the area that once housed the Boatyard Village.

Since the village was only built in the 1970s, it is odd that she is described as wearing turn-of-the-century period clothing. As she frequented the theater, it is assumed it was a costume. Several deaths occurred in the area of the Boatyard Village, but none involved a young lady in white, and certainly no records exist of anyone dying at the theater. So one simply has to wonder, who is the lady in white, and why does she haunt a place that now exists only in memory?

The Cinder Lady

St. Petersburg

Mary Reeser had spent the evening of July 1, 1951, with visits from her son and a neighbor. Miss Reeser was wearing her rayon nightgown, some slippers and a robe. Her guests left the sixty-seven-year-old lady, and everything was quite normal and unremarkable.

The next morning, a telegram courier arrived and knocked at the door to Reeser's apartment. When there was no answer, he checked the neighbor next door. When the neighbor came back with the courier, they tried knocking again, as the neighbor knew Reeser rarely left the apartment. With still no answer, he noticed the door was hot to the touch and quickly alerted the authorities.

Police arrived and managed to get into the apartment. Once inside, they noted it was unusually warm even though the windows were open. In one corner of the apartment they found a pile of ashes, which were the burnt remains of a chair and lamp. There was a partially melted clock that had stopped at 4:20 a.m. when the power plug it was inserted in had melted. Other than the charred remnants in this corner, the apartment was seemingly untouched by any fire damage. It was when they looked closer at the ashes that they discovered a woman's left foot still wearing a slipper. Sifting through the ashes, they found a miniaturized human skull. That and the foot were all that remained of Mary Reeser. Mary had weighed nearly 170 pounds, and all that was left weighed less than 10.

The FBI came and investigated the strange death at the behest of the local police. They determined that Reeser fell asleep while smoking, and

A photo of all that remained of Mary Reeser after the fragments, foot and slipper were sent away. This photo is from the original investigation file from the FBI. *Courtesy of the St. Petersburg Museum of History.*

the damage to her body was so severe thanks to a phenomenon called the "wick effect." Sometimes called "candling," this is where the clothing of a victim soaks up the melted fat and acts like the wick of a candle. The police disagreed with the assumption, and the case was not closed.

Mary's apartment clearly showed signs of high heat. Walls were covered with greasy spots, and a mirror had cracked. Plastic power switches and two candles on a nearby dresser were melted. Experts claimed the extreme temperatures needed to do that much damage would need to be over 2,500 degrees Fahrenheit. A cigarette could never have produced that high of a temperature, even if it had ignited the chair or her robe. The FBI pathologist saw no signs of gasoline. Even ball lightning was considered, but no storms had occurred the night of her death.

On July 7, the police chief of St. Petersburg, J.R. Reichert, sent a box of evidence to FBI director J. Edgar Hoover himself. He included fragments found in the ashes that were six "small objects thought to be teeth," some

carpet and the surviving shoe. He requested any theory or information that might prove helpful since so much damage was done to the body but so little to the surrounding apartment that there wasn't even much smoke damage.

To the experts, clearly this was no ordinary fire. They estimated that a fire of 2,500 degrees would need to be burning for several hours to consume a human being so thoroughly. A fire that hot and burning for that long should have destroyed the rest of the apartment, if not the entire building. There was no simple answer available here.

Months after her death, Mary Reeser's death was attributed to "falling asleep with a cigarette" by the FBI investigation, even though most experts had already concluded such a fire was nearly impossible. The declaration, however, from the chief of detectives and the chief of police served to close the case publicly.

The question remains as to what truly happened to Mary Reeser. Was this ball lightning, or was it a true case of spontaneous human combustion, as

While there are some signs of fire damage in this picture of Mary Reeser's couch, the intense heat needed to destroy her body so completely should have also incinerated much more of the furniture. This photo is from the FBI file. *Courtesy of the St. Petersburg Museum of History.*

many like to believe? There are wild theories about ghosts, magic and even alien abduction. Now Mary's case is simply known as the "Cinder Lady."

One of the consultants on the case was noted physical anthropologist Wilton Krogman. His views on the case went unknown until he wrote about it in 1961, nearly a decade later:

> *I find it hard to believe that a human body, once ignited, will literally consume itself—burn itself out, as does a candle wick…..Never have I seen a body so completely consumed by heat. This is contrary to normal experience, and I regard it as the most amazing thing I have ever seen….As I review it, the short hairs on my neck bristle with vague fear. Were I living in the Middle Ages, I'd mutter something about black magic.*

Sometime after this publication, Krogman would walk back this statement. He postulated a theory later that involved Reeser being murdered elsewhere and taken somewhere with cremation capabilities, which incinerated her body partially. The remains were then transported back to the apartment to hide the crime by using heat-generating devices to help add finishing touches. That would be a long way to go to hide the murder of a sixty-seven-year-old retiree.

What truly happened we may never know. If nothing else, it serves as a warning to never fall asleep with a lit cigarette.

MINI LIGHTS

St. Petersburg

*F*lorida's strangest legend of all comes from what one would assume to be the most surprising location in all of Florida. St. Petersburg is called the Sunshine City, for it holds the record for the most consecutive days of sunshine in a state known for its sunshine. For a city that has so much light, you would think it odd to discover that it has a large reputation for ghostly activity. The city has a truly dark history filled with massacres, mobsters, murders and the ghostly apparitions frequently associated with them.

One tale, however, is so odd that it could only find its home here in eerie Florida. It is spoken of only in whispers in southern Pinellas County. While investigating this legend, we were told more than once, "Don't you go messing with the mini lights!"

The story begins in the mid-1920s with a lady who either was a Mennonite or had the improbable name of Minnie Lites. The woman ran a boardinghouse just south of downtown St. Petersburg. The exact location is not precise but is estimated near where the domed stadium known as Tropicana Field now stands. This area housed many boardinghouses around that time for railroad workers and early builders of the booming metropolis that would become St. Petersburg proper. Most of this area has been redeveloped in recent years into condos and the new art district. There are still numerous old multi-room buildings from that era that have been converted into apartment living or even bed-and-breakfast hotels.

The proprietor of the boardinghouse was known to be a gracious and generous hostess, but the locals were unhappy with her quality of tenants.

What tends to lend credence to the legend of her being a religious woman is that she allowed undesirable types, including minorities and even circus freaks. Since the Ringling Circus summered in Sarasota just south of Tampa Bay at that time, there were many circus talents and acts migrating to the area hoping to join the Big Top. Several smaller circus companies sprang up in this boom to try to capture some of Ringling's success. This population boom of circus folk turned several local towns into complete circus towns with the promise of careers for those seeking them. The most notable such town was Gibsonton, just across the bay from St. Petersburg, which to this day has a reputation for housing circus freakshow descendants and many famous circus performing families. The boardinghouse hostess apparently catered to these curious individuals as a specialty.

According to the legend, the local populace would frequently torment the nice lady and her boarders by throwing rocks at her house and shouting her name, "Minnie Lites!" or as we discussed earlier, it is more likely they were shouting "Mennonite!" This drove the boarders into a furor. It was said that two of the circus folk, described as dwarves with some sort of scaly skin condition, would come out with large wooden baseball bats and chase away the crowds. Apparently, this entertained the crowd more than it scared them, so they would return very often to repeat this ritual. It had become so prevalent in the stories we've been told that you can supposedly still hear the chanting on evenings near the Roser Park area of St. Petersburg after the sun sets.

The story goes that one night, the crowd got so rowdy that they threw torches instead of rocks and fruit, and the house burned down. Records are spotty at best in those early days of St. Petersburg, so there is no real way to know if this event occurred for certain. There was a famous arson circus fire in St. Petersburg around that time that might be merging with this legend. It is here where the story gets even stranger. Our story does not even begin to end here.

One version of the legend states that if you go to the area where the house once stood and shout "Mini lights" three times, then ghostly green lights will come out and chase you. This is the most prevalent form of the legend we heard, a simple ghost story with an almost "Bloody Mary"–like incantation to trigger it.

Another version says that the area around Roser Park in St. Petersburg is now the home of little green-skinned men that sometimes come out of the sewers and chase you down with baseball bats if you provoke them by repeating the words, "Mini lights." Some of those stories even claim that

The entrance to beautiful Roser Park.

instead of several creatures, there is actually only one large creature that is a large green-skinned troll that comes out if you scream his name, Mini Lights, at midnight.

The area of this legend is just south of downtown and has become a beautiful park. Roser Park was founded by Charles Roser, thought by many to be the man who invented the Fig Newton. Not being able to buy land in a large lot like so many other developers, he bought his property piece by piece along the small creek that rolls through this area and developed his park along its shores slowly. Sadly, it is not as popular as other local parks due to its proximity to troublesome crime-filled areas in St. Petersburg. It stretches along Roser Creek all the way down to where world-famous All Children's Hospital stands today.

Perhaps the strangest version of this legend is that the dwarves fled into the sewers after the boardinghouse burned down and have built an entire inbred society of alligator-skinned people in the sewers of St. Petersburg that hunt the south side of the city after dark for small animals or even children. Many a parent in the south of St. Petersburg warn their children not to stay out late or "the Gator Boys will get you."

While asking around about this version, we encountered a local gentleman named Lou who asked to not be further named. He told us yet another version of this tale. The lady in question was not a Mennonite, nor did she

own a boardinghouse. There was no fire. There were no circus folk. These were all just legends trying to make sense of the real hidden truth, according to Lou. The truth was all of this was just propaganda and stories to hide Minnie Lightning, the voodoo queen of St. Petersburg.

Minnie Lightning had been in Tampa Bay since the earliest days of white settlers in St. Petersburg. She was brought here as a slave but escaped after bewitching and seducing her master. She is a weather witch who lives forever. She is the real reason that Tampa Bay is known as the lightning capital of the world. She is also yet another reason that hurricanes never seem to directly impact the Tampa Bay area. Her magic simply steers them away.

Minnie Lightning has ten little green men at her beck and call who live under the Roser Park Bridge. The men are animated corpses with shrunken bodies and heads that are painted green by the priestess. Their eyes glow with a fiery red light. At night, the little green men come out of "the Jungle." They call the area under Roser Park Bridge "the Jungle," as it has a swamp-like clump of trees with thick Spanish moss hanging from them in an unlit area. Minnie's men grab unsuspecting victims who make too much noise or speak ill of the priestess. The men take them back to Minnie's altar in an abandoned house. There she performs rituals on them. It is still often said that when something terrible happens in this area of St. Petersburg just south of downtown, Minnie Lightning and her ten green men are to blame.

Lou told us that in the late summer of 1978, a preacher's daughter at his church went missing after dark. He and his friends were convinced that she hadn't run off but that Minnie Lightning must have sent her men to get the young girl. Lou said he and his friends reasoned that the old lady who lived in the old white house north of the Roser Park Bridge must really be Minnie Lightning. They surrounded her house and started pelting it with rocks, demanding Minnie Lightning and her green men let the girl go.

I asked if he saw little green men or little lights. He replied that he and his friends certainly saw lights, which caused them to run. The police were coming after them! As they ran, the little old lady came out of her front door and yelled at them, "Minnie Lightning don't live here!"

Lou said the preacher's daughter showed up unharmed a few days later; she had simply run away after all. His friends said they felt so bad that they each took part-time jobs and saved all their money. They gave it all to the little old lady at the end of the summer. She was thankful but told them to never come near her house again. She told them she knew the real Minnie Lightning. She would have her little voodoo men hunt them all down if they ever came back.

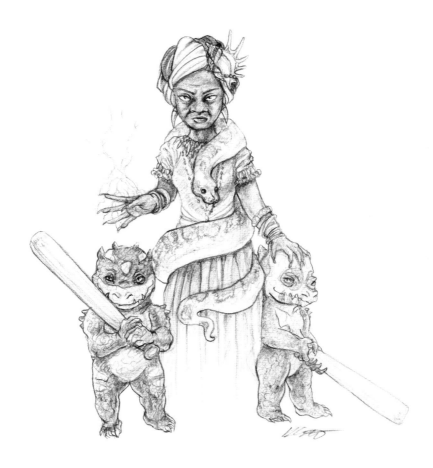

Minnie Lightning, the voodoo queen of St. Petersburg, and some of her green men.
Illustration by Kari Schultz, 2017.

One last version we heard was from a local child named Alex who was playing near Roser Park with his parents as we went to take pictures for this entry. Alex spoke about being told never to go over Roser Park Bridge alone or to cry out because a terrible troll named Mini Lights would come out and attack you. If he got you in his mouth, he would take you back to his home in "the Jungle" where he eats children. The child also said that the troll is afraid of cement, so if you stay off the grass and on the cement path, he can't get you.

Which version is the true legend? As always, it is hard to find solid evidence, and the city of St. Petersburg certainly doesn't seem to be aware of a large population of diminutive alligator people in its sewer system. It is telling that while researching this book, many people told variations of this legend that all had similar enough connections to the original tale. Most agreed it sounded improbable or even silly. However, many people were seriously afraid to talk about it at all. More still gave that ominous warning again: "Don't you go messing with the mini lights."

Tales of ghostly phantoms abound at St. Petersburg's famous landmarks, including the Don CeSar, the Vinoy Hotel and Fort DeSoto. If you would like to know more about these ghostly tales, I suggest you read *Ghost Stories of St. Petersburg, Clearwater and Pinellas County: Tales from a Haunted Peninsula* by Deborah Fretham, also from The History Press.

LOST CEMETERIES OF TAMPA BAY

St. Petersburg

*T*he town of St. Petersburg, Florida, on the Pinellas Peninsula is known for its beautiful weather, and according to TripAdvisor, three of the top ten beaches in the world are just minutes away. It is no wonder, then, that the earliest natives of this continent once had a thriving community here and lived among the mangroves on the shores of Tampa Bay. Their shell middens and burial mounds were plentiful all over the Pinellas Peninsula.

Known as the Weedon Island culture by archaeologists, the natives of this area are the earliest human inhabitants we know of in this area. Though long gone by the time of the early European settlers, explorers including Hernando De Soto encountered the remnants of these people and hoped they would guide him to lost golden cities or even the fountain of youth.

One other early visitor to the area that is now part of Pinellas County was named Panfilo de Narvaez, a Spanish explorer and conquistador soldier. He had helped conquer Cuba in 1511 and was sent to lead a royal expedition for Spain into North America in 1527. Hit by a hurricane shortly after leaving Cuba, he came aground near a mound in what is now St. Petersburg. He was befriended by the local Indians, who supplied his continued journeys and wished him well as he was to travel farther north in search of Indian cities of gold. At sea, he once again encountered a terrible storm, perhaps even the same hurricane that had damaged his fleet before. Turning back to the Florida shore, he encountered hostile Indians this time.

To make matters worse, his pilot sailed for Mexico, leaving his men stranded on a hostile shore. Narvaez had what was left of his men make

their way back to the tribe that had helped them before. This time, they were not greeted with open arms, and so they attacked the Indians who had helped them. The few Spaniards who survived made rafts and set sail west for Spanish colonies in Mexico. Three of the rafts sank, but some of the eighty men made it and reached Galveston Island. Narvaez did not survive.

Before the Civil War, only five families had homesteaded in the area that was to become St. Petersburg, according to records. By the end of the war, only three families remained. Most of the settlers had decided to stay north of Tampa Bay out of fear of restless natives or just not daring the unknown wilds of the Florida swamplands, beautiful beaches or not. The land was much more fertile for crops inland.

That all changed when, in 1875, a retired general named John Williams came to the Tampa Bay area from his home in Detroit and purchased over 2,500 acres of land. He planned to found a great city with parks and broad streets. He built a beautiful hotel and named it after his home. The Detroit Hotel is still standing, though converted to condos in 2002.

Sometime later, a Russian aristocrat named Peter Demens purchased the Orange Belt Railway and brought it to St. Petersburg. He had built the line with unpaid workers and was facing bankruptcy when the railroad finally made its way into the city on June 8, 1888. The story goes that Williams and Demens flipped a coin to name the city. Demens won the toss, and so

A section of a map created by the City of St. Petersburg, Florida, Department of Public Works, depicting a proposed connection of Sixteenth Street South over a map of St. Petersburg. *Author's photo in the St. Petersburg Museum of History Archives, 2017.*

Left: The corner of Hillview Road and Shade Street in Sarasota was once possibly home to the never-reported-moved Hillview Cemetery. Now it is a beautiful suburb of homes with a nearby park.

Below: A *Tampa Tribune* photo from the 1940s showing the paving of Central Avenue in St. Petersburg, causing the discovery of the lost Lumpkins Family Cemetery. *Courtesy of the St. Petersburg Museum of History.*

it was named after his birthplace in St. Petersburg, Russia. The city was incorporated in 1903.

The city grew exponentially after the arrival of the railroad, with settlers spreading word of the excellent weather all year and amazing beaches. The land rush was suddenly on. There was just one problem: all of these strange mounds were everywhere. Most were shell middens that the natives of the area had used as garbage dumps of their oyster, conch and snail shells. Some, however, were burial mounds. Early settlers of the area didn't care which was which and either plowed them under or even built on top of them. One famous instance of this was the developers of the Tierra Verde neighborhood. They simply bulldozed several mounds and used the material within to pave the roads of the area.

When a massive storm came in 1922 just as the population boom was reaching its peak, many people fled the area, never to return. When new families and developers would come to the area, they would find beautiful flat plots of land with no buildings on them. They assumed these areas must have had houses destroyed by the storm, so they would build on these plots. What they didn't realize is they were building on the town's original cemeteries.

The Oaklawn Cemetery, the Evergreen Cemetery and the Moffett's Cemetery were developed over and are underneath where the famous Tropicana Field Dome Stadium and some of its parking lot now stand. The Lumpkins Family Cemetery is estimated to be right off Central Avenue where now stand a bevy of boutique stores. There are no records of the cemeteries ever being moved.

These lost cemeteries are not unique to St. Petersburg, as many researchers have tried to find them throughout the Tampa Bay area. Hillview Cemetery was an early pioneer graveyard in Sarasota. It was located at the corner of Shady Point and Hillview Roads. As there is no Shady Point Road anymore, it is difficult to find the true location. We did find Shade Street and Hillview Road, where houses now stand, though a small park is just a few blocks away that may have been the original location. Would it be worrisome to wonder if your bedroom lies over a graveyard?

Stories of these lost cemeteries or newly discovered burial middens are quite frequently in the local papers. The Glen Oaks Mound and Cemetery has now been preserved, as have the Weedon Island mounds. The Glen Oaks cemetery is the earliest surviving cemetery from those nineteenth-century pioneers, and the fact that it lies next to one of the only surviving burial mounds in St. Petersburg makes it one of the greatest treasures for

historians of the area. Several more mounds have been preserved, but with so many lost, it is unknown how many there actually ever were.

Once again, legends tell the tales of graves and human remains being discovered in gardens and as new foundations are dug for renovations. Anywhere the land rises more than twenty feet in the city, one has to wonder if it is actually a midden or burial mound, as there aren't many hills naturally in this area of Florida. According to the city's website, it is the sunniest city in America, and they used to give the evening paper away for free on days with no sun. However, the Sunshine City has a very dark side indeed, as it was built on an unknown number of buried dead.

THE DANCING GENTLEMAN GHOST

Gulfport

In the 1880s, the Pinellas Peninsula of St. Petersburg was still largely unpopulated, with the exception of downtown St. Petersburg itself. In the 1860s, Captain James Barnett and his wife, Rebecca, had built a home near the shoreline of the Gulf. Joe Torres and William Bonafacio soon built houses nearby. The area around them became known as Bonafacio and stayed that way until 1881. Hamilton Disston purchased over 150,000 acres of land in southern Pinellas County at the time and platted twenty-five square miles of it to be called Disston City. The new city was built to house fifty thousand and would include an expensive hotel called the Waldorf. The city would have a new pier with a great community center to attract and entertain prospective families.

By 1886, the population had reached only 150 people. Disston needed a railroad into Pinellas and went to his friend Peter Demens. He had hoped to bring Demens's Orange Belt Railroad not only across Tampa Bay to St. Petersburg but also over to the largely unpopulated Disston City. In 1888, the railroad was completed to St. Petersburg but did not go on to Disston City. This made the area only accessible by water and a steamboat named the *Mary Disston*.

In 1892, the *Mary Disston* was engulfed in flames at the dock in Disston City. The boat had to be set adrift into the bay, where it sank a short while later. The city went into decline with no regular means of access. The dream seemed lost forever.

A monument on the current Gulfport pier marks the sinking of the *Mary Disston* with an etching so you can see how the ship would have looked out in the bay.

Sometime in the early 1900s, St. Petersburg's electric trolley system was extended from St. Petersburg into Disston City. A former soldier named Captain Chase planned a retirement community for his fellow Civil and Seminole War veterans in the area. Disston City became known as Veteran City. The area around the trolley line was developed, and the pier and casino were finally constructed. The Singlehurst Mill opened shop and assisted in clearing the mostly wooded areas. It also helped produce the wood for the pier and casino. Despite all of this, Veteran City did not draw large numbers of retired soldiers. On October 12, 1910, the town was finally incorporated under the creative name of Gulfport, seeing as it was a port on the Gulf of Mexico.

The word "casino" today usually seems to draw one's attention to a gambling hall like in Las Vegas or those operated by the Seminoles throughout the state of Florida. Gulfport's casino was far different; it was merely a place for social gatherings. The trolley line had been built by Frank Davis, and the idea was to connect boats that would carry passengers to the popular Pass-A-Grille Beach. The seven-hundred-foot-long dock was built out into the bay and electrified and lit, which gave it another colorful nickname: the Electric Dock. Trolleys rolled down what is now Beach Boulevard and went all the way to the end of the dock, where passengers would wait at the Casino for the boats to arrive.

The building at the end of the pier was known as the Casino, the Gulf Casino or merely the "Dock and Spa." The Dock and Spa was the name of

the last stop of the trolley; hence, it seemed to stick. It was built in 1906 as a place for people to rest while they waited for a boat to ferry them to the beach shores, as there were no bridges at the time. The building itself had become quite popular on its own thanks to the trolley. The building housed a post office and a nice little refreshment stand with a shop that sold postcards, shells and other souvenirs, as well as the candy and soft drinks it was known for. A small apartment for the couple who ran the shop was in the building, but it was most known for its open-air pavilion on the second floor, which held a dance hall and stage.

For fifteen years, the Casino made Gulfport hugely popular for residents of Tampa Bay. In 1921, one of the worst hurricanes ever to affect Tampa Bay came close to shore and destroyed the original Casino and pier. There was nothing left of the pier or Casino after the storm but bits of debris.

In 1924, a second Casino opened up. The new structure was closer to the shore and took the style of the first Casino. It was not as strongly built as the first, as it was only temporary while a new, superior Casino could be built right on the coastline. People still flocked to the new Casino to dance and socialize. Automobiles were becoming more popular, and many of St. Petersburg's roadways were now paved with brick. The trolley's days were numbered, but the people still needed the ferry to get out to the beaches.

A postcard showcasing the original Gulfport Casino from around 1918. *Courtesy of the St. Petersburg Museum of History.*

The dancing gentleman ghost of Gulfport waltzing for eternity. *Illustration by Kari Schultz, 2017.*

The third and final version of the Casino was built on the shore in 1934. Though it has been remodeled from time to time since then, it is still the same building built in 1934. It is currently home to many social events like weddings, town hall meetings and, of course, dancing. A bandshell stage lies next to a five-thousand-square-foot dance floor with art deco chandeliers hanging overhead. It is rented out frequently for special events, though dance classes are offered there many nights a week.

However, there is one reason why it is listed here. One of the original Casino's patrons still likes to dance on the old second-story ballroom of the first Casino, even though it was destroyed in 1921. The phantasmic figure, dressed complete with tux and tailcoat, is seen waltzing with an unseen

The new and final Gulfport Casino as it stands today.

partner about twenty feet above the water. He is quite literally dancing on air. Fishermen and tourists alike have reported this ghost for dozens of years. Some versions of the story say you never see his face. One version says his neck is at an awkward angle and he has a horrific smile affixed to his face, as though smiling through the anguish of an eternal dance.

The exact area is by where the old Casino was, which is now open water. You can see the shadow of the famous Don CeSar Hotel on Pass-A-Grille Beach behind him as you look out toward the Gulf of Mexico. The best time to see this reported haunting is near dawn, as the first shreds of light are coming into the bay. Some witnesses say that they've seen him dance for long periods even after the sun has risen.

Today, the city of Gulfport houses a strong art community and is the home of many fine shops and restaurants. There isn't a trolley there anymore; the pier is more for fishermen and sightseers. There are no more ferries to the beaches, as there are several bridges nearby that do the job quite adequately. The ballroom is always packed with events or dance classes. The old dancer, though, is still seen on occasion waltzing with his invisible partner just a few hundred feet away in the morning sun.

THE SUNSHINE SKYWAY BRIDGE

Tampa Bay

*I*n the early 1950s, there was a great plan to build a giant bridge from southern St. Petersburg in Pinellas County to Terra Ceia in Manatee County. This grand bridge would cross the southern mouth of Tampa Bay and thus go through yet a third county, since the waters belong to Hillsborough County. When the bridge opened in 1954, it was not the first bridge to cross Tampa Bay, but it was the first bridge to cross the southern gap of the bay. The span helped cut the usual drive time of several hours from Bradenton to St. Petersburg to less than an hour. It was a wonder of engineering, but it was to be marked by several tragedies for years to come. This has led to so many ghost stories and legends surrounding the bridge that many call it cursed.

On May 9, 1980, the large cargo ship *Summit Venture* was coming into the port of Tampa. It was in the early hours of the day, and Bruce Atkins was assisting harbor pilot John Lerro. The harbor pilot was nearing the turn that would guide them under the Sunshine Skyway Bridge, which rose to over 150 feet above the bay, when suddenly the wind changed direction and a sudden tropical storm appeared out of nowhere. Tropical rains and sudden storms are common in Florida and can seemingly spring up on a moment's notice. When this storm came, there was a sudden blinding rain and gusts that were likely greater than seventy miles an hour. The boat began to turn sideways.

As the sunlight started to come back through the clouds, Lerro realized how off course the boat was and ordered the anchors dropped and the

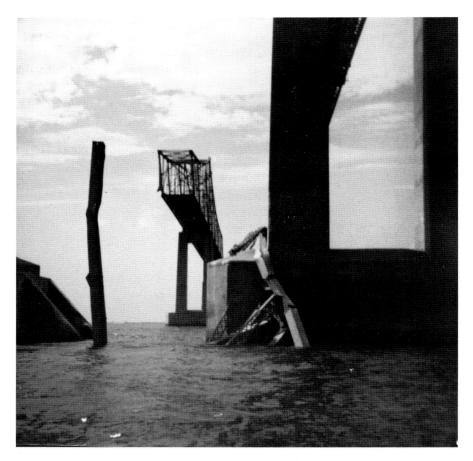

A private photo of the wreckage of the collapsed span of the bridge taken by a rescue boat. Note how far the vehicles would have fallen before hitting the water. *Courtesy of the St. Petersburg Museum of History.*

engines full astern, but it was far too late. The twenty-thousand-ton vessel was drifting toward the bridge. It scraped the second pier of the bridge, and the whole middle span collapsed. Lerro was five hundred feet away in the wheelhouse of the *Venture* and could do nothing.

Within moments, a Greyhound bus drove off the collapsed span and plummeted through the steel and girders into the waters of Tampa Bay below. Car after car continued off the bridge as the rain made it nearly impossible to see ahead.

Lerro placed a distress call, which can be heard at the archives of the St. Petersburg History Museum. It is a frantic call, John Lerro is trying

desperately to get the Skyway to close to traffic: "The bridge is down. Get all emergency equipment onto the Skyway Bridge. The Skyway Bridge is down. This is a major emergency situation. Stop the traffic on that Skyway Bridge."

In all, thirty-five people lost their lives that day. The *Summit Venture* picked up the only survivor, who landed on the deck of the ship. Up on the bridge, Richard Hornbuckle in his 1976 Buick was able to stop as he saw the lights of a car in front of him fall off the bridge just as the squall died down. He and his passengers, though dazed and in shock, walked down the bridge and alerted other drivers to stop any others from driving at seventy miles an hour off the 150-foot drop into the bay below.

When work began on the replacement bridge, it was built to prevent just such a disaster from ever occurring again. Not only did they raise the height and widen the channel underneath, but construction also included barrier bumpers that could withstand nearly thirty million pounds of force. Rock islands were secured around the center piers, and the whole bridge

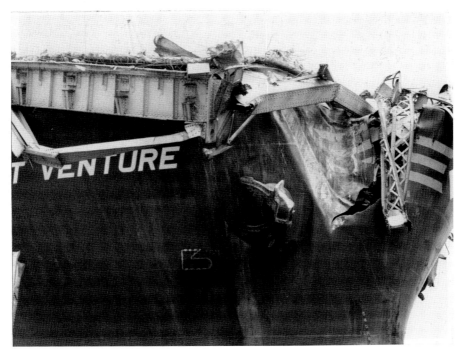

A photo of the bow of the *Summit Venture* with some of the wreckage of the Skyway Bridge still on it shortly after the disaster. *Courtesy of the St. Petersburg Museum of History.*

was moved farther away from the sharp turn so that ships would have much more room to maneuver. All of this was in the wake of the *Summit Venture* disaster.

While this was by far the worst disaster and most infamous involving the bridge, just a few months prior in January 1980, the worst peacetime disaster in coast guard history occurred just two miles south of the Sunshine Skyway Bridge. The high volume of the shipping lanes and the notoriously difficult, narrow navigation were well known at the time. The U.S. Coast Guard buoy tender *Blackthorn* was replacing navigational markers when it was blinded by the bright lights of the Russian cruise ship *Kazakhstan*. This caused the vessel to collide with the oil tanker *Capricorn*, carrying nearly 152,000 barrels of oil. There was initially only minor damage, but the *Capricorn*'s anchor, which alone weighed nearly seven tons, hooked the *Blackthorn*. Once the line became taut, the small coast guard cutter was pulled over and capsized within minutes in forty-foot-deep water.

Of a crew of nearly fifty sailors, twenty-three died. The heroic actions and sacrifice of a young sailor named Seaman Apprentice Billy Flores helped save so many of his fellow crew mates. He climbed onto the deck of the quickly sinking *Blackthorn* and started throwing life vests to his fellow crew. He then used his belt to tie open the storage locker where the vests were as the boat capsized, hoping that life vests would float out and be able to be used by his fellows. Sadly, this was his last act of bravery, as he was pulled under the capsizing boat. For his actions, he was posthumously awarded the Coast Guard Medal in September 2000.

Thankfully, the waters of Tampa Bay were mildly warm, as is common in January in Tampa Bay. No storms hindered rescue efforts, or else more lives might have been lost. The *Blackthorn* itself was stripped of all useful metals and today lies around twenty miles off Clearwater Beach as an artificial reef. Each year, the coast guard holds a memorial service there.

The dark history of the Skyway Bridge doesn't stop there. At the time of the writing of this book, at least 220 people have committed suicide by jumping from the center span since the new bridge opened in 1987. Over 30 other lost souls have tried to end their lives by jumping off the bridge but have survived. From 1954 all the way to 1987, 51 people jumped to their deaths from the previous Sunshine Skyway Bridge. Two famous cases include Michael Plezia, who had been kidnapped and tortured and was forced to jump at gunpoint in 1981. On the Fourth of July in 1992, a young man from Sarasota hanged himself from the bridge.

There are now six crisis hotline phones along the span of the road. The state now has officers cross the bridge constantly, with a "suicide watch patrol" trained specifically for talking down potential jumpers. Stopping on the bridge for any non-emergency, including photography or sightseeing, is strictly prohibited. Since it is a controlled-access highway, pedestrians and bicycles are also prohibited. Many lives have been saved since the implementation of these prevention methods, but attempts and successful suicides still occur with frightening regularity, and as stated by some members of the highway patrol, the number of attempts actually seems to be climbing in recent years.

Is it any wonder that a bridge so associated with death would have a haunted history to coincide with it?

The most famous and most frequently spotted ghost along the span is that of a lone hitching ghost. A young girl wearing white seems lost and dazed as she crosses the span. Friendly travelers stop to help the poor girl and hopefully prevent a tragic situation that so frequently occurs on the bridge. The girl gets into the vehicle and says nothing, usually shaking and looking very wet. At some point, the driver looks away, and she vanishes without a trace, as though she was never there at all. Her appearance is so commonly reported to the tollbooth operators that most simply reply with, "Oh, you met our ghost." Her initial sightings go so far back that they were on the old

The *Blackthorn* memorial, with the ship's original anchor at the park near the Sunshine Skyway Bridge.

span. This ghost seems to have migrated to the new bridge, as reports of her continue to this very day.

A less common sighting occurs on the fishing piers that were created from the remains of the span of the older bridge. This sighting is spoken of by fishers along that pier. They state that in the early morning just as the sun rises over the bay, they hear the engine of a large vehicle coming down the span. As it is closed to traffic, that alone is cause for concern. Then the image of the old Greyhound bus that crashed on that fateful day can be seen driving along the bridge toward its inevitable final destination once again. The most terrifying piece of this story was told by one eyewitness, who claimed that he could see every one of the faces of the passengers just screaming as they hurtled past—except for the last passenger in the passing windows. "He was just smiling."

The area around the bridge is so associated with tragedy and death that local boaters have a legend of their own, a legendary creature

Above: The view of the new Sunshine Skyway Bridge over the mouth of Tampa Bay, where you can see pieces of the old bridge still crumbling in the waters below.

Opposite: A photo showing the capture of a large hammerhead in St. Petersburg in front of the old electric trolley system from the early 1900s. *Courtesy of the St. Petersburg Museum of History.*

drawn to the blood in the water. A creature supposedly at least twenty feet long and as white as a ghost. While certainly no Moby Dick or Jaws, it is another legendary albino marine creature. This giant hammerhead shark has the unusual nickname of "Old Hitler." Reports of his sightings and "almost caught him" stories abounded in the mid-'80s and late '90s, but there are still reports of encounters with him as recent as the time of this writing in 2017.

For decades, the shark has dodged fishers, and it is supposedly covered with scars from near misses with harpoons and hooks. Apparently one person attacked it with a machete. The stories of the shark are as legendary as the beast himself. There are tales of him jumping into boats to steal fish off hooks. The greatest tale is of Old Hitler dragging a jeep off the old Skyway Bridge after getting jabbed with the car's tow cable, which was in the waters of Tampa Bay.

The stories drew the attention of the Discovery Channel in 2014, and it was featured on the program *Monster Hammerheads* during the channel's popular annual "Shark Week" event programming block. The show spotted numerous sharks in the bay but not the ever-elusive Old Hitler.

The "Old Hitler" moniker came during World War II. German U-boats were a significant threat to ships off the Florida coastline. The coast guard and the navy used blimps to try to spot the submarines. Many of the sightings turned out to be large hammerheads that frequent the waters of the Gulf and the mouth of Tampa Bay. The "Old Hitler" reference was one that was too easy to simply ignore, and the legend grew from there. There are more recent reports that the shark even has a scar on his hammerhead that resembles a swastika.

It is very unlikely that all the legends come from the same shark; however, there are hammerheads greater than twelve feet long sighted in the Gulf of Mexico regularly. The sharks follow the tarpon school runs that run all over the Gulf coast of Florida from the Keys up to the panhandle. Large hammerheads would be capable of nearly all of the legendary exploits attributed to Old Hitler. The largest hammerhead ever captured in the Gulf of Mexico was in 2008 and was over thirteen feet long and weighed nearly 1,400 pounds. Thankfully, hammerheads are rarely a threat to humans, but blood in the water can cause any shark to change its demeanor. Included on the previous page is a picture from the archives of the St. Petersburg Museum of History's Archives where two St. Petersburg fishermen stand next to a landed hammerhead shark over ten feet long as early as 1914.

So when driving across the Sunshine Skyway Bridge, keep your eyes open for the beautiful drive. The sunsets and sunrises are particularly splendid as you drive the long bridge at the dizzying heights. Just make sure to watch for hitchhiking ghosts, a haunted bus and a legendary shark that might give the Loch Ness Monster a run for its money.

If you'd like to know more about the history of the bridge, you should read *The Sunshine Skyway Bridge: Spanning Tampa Bay*, written by Nevin and Richard Sitler, also by The History Press. Written in 2013 with the help of the St. Petersburg Museum of History, it is a fascinating tale of every attempt to span the bay and all that went into completing the original span and the more modern replacement that had to be built after that fateful day in 1980.

SARA DE SOTO
AND THE SPIRITS OF THE BAY

Sarasota

*T*he area of Sarasota is beautiful and peaceful. This idyllic land was to be the winter home of John Ringling. There he built a beautiful mansion with an amazing collection of art. The gardens and beaches of Sarasota are among the most popular destinations for tourists in the world. They also seem to dodge the worst of the hurricanes and tropical storms that frequent the Gulf coast of Florida. Of course, there is a legend as to why.

In 1900, a historian named George F. Chapline of Clarendon, Arkansas, overheard some local natives telling the tale and wrote an account of the legend that Sarasota still proudly displays on its website.

The legend begins with a famous native chief named Chichi-Okobee. This proud and fierce warrior led many men to the camp of the great chief of the white men they knew as De Soto. Hernando De Soto was already well known by the natives as someone to be wary of but generally dealt fairly with the local tribes. Chichi-Okobee came in peace to the great white chief. He surrendered in order to spare the lives of his people. He offered to be their hostage and guide if needed, for he had glimpsed De Soto's beautiful daughter Sara, and the young native had fallen in love with the dark-eyed foreign maiden.

De Soto was happy to have a guide who would assist them through the harsh wilderness looking for golden cities of legend. Chichi-Okobee endured imprisonment and the harshness of his captors without a word of complaint. He led them deep into the swamps and told them there were no golden cities to be found, but De Soto did not believe him and force marched his men deeper into the Everglades.

Sarasota Bay as seen from the Ringling Museum grounds.

Chichi became very sick from the imprisonment and eating the food of these white men. The white doctors could not cure him, and he was miles away from his medicine man. He was dying of fever in the deep swamps of Florida. Sara De Soto then asked for permission to minister to the dying Chichi-Okobee. With her touch and soft words, a miracle occurred, and Chichi was healed. His heart had been restored by the love of this strange visitor to his world. Sadly, it was then that Sara began to fall ill with fever. The doctors again could not help the young lady, and Chichi begged De Soto to let him return to his home to fetch the mighty medicine man Ahti. This shaman was so powerful that he could bring back a heartbeat of those thought long dead. Ahti knew all the spirits of the Everglades and could bind them to his work. He could cure the young maiden.

De Soto let the young chief go, and Chichi ran back to his village as quickly as anyone has ever witnessed. De Soto began his long march back out of the swamps with his men, with no cities of gold plundered and now a sick and dying daughter his price to pay. His men were also concerned that he had let the native escape and he might warn other tribes about them. They might be walking into an ambush.

A month passed before Chichi-Okobee and Ahti the medicine man arrived outside the tent of the dying Sara De Soto. Strange spells were weaved by the old shaman and herbs were burned in the tent of the dying girl. Chichi

129

Chichi-Okobee solemnly stands over his lost love, Sara De Soto, as they sail with an army of Indian warriors into eternity to protect her final resting place. *Illustration by Kari Schultz, 2017.*

stood watch outside the tent without uttering a word for days as he watched his love slipping away despite the efforts of the mighty Ahti.

At long last, Sara passed away, being called by the Great Spirit. Ahti had been outmatched by a power even greater than his own. Chichi was distraught and heartbroken. He then went to De Soto and spoke of his love for the lost girl. He asked that he might select the place and ceremony for her burial. De Soto was apparently quite moved by the native and agreed.

The young chief told them of a peaceful landlocked bay where he wished to bury his beloved. He went to his camp and came back with a body of one hundred Seminole braves, with him at the head. All wore full war paint and had full quivers and spears. De Soto's men were more than slightly concerned, as the warriors were known to have poison arrows and spear tips. They felt their fears of an ambush were justified.

The braves did not attack. They formed behind Chichi-Okobee and bore the remains of Sara De Soto into a canoe. Three more large canoes covered with the moss of the forest were brought forth, and the boats were boarded by the braves. The lead boat held Chichi and Sara as they drifted out into the bay.

At a shout, the war canoes with the hundreds of braves all brought out their axes and chopped their own canoes into pieces. As the hundred braves and Chief Chichi-Okobee sank into the surface of the still bay, De Soto and his men stood astonished.

Sarasota Bay, as it is now known, is very peaceful and beautiful. The Seminole tribe still tells this tale of Chichi-Okobee and his warriors protecting the bay from evil spirits and the storm god. They hold the pass to the Gulf of Mexico and protect the resting place of Sara De Soto.

Could it be that the whitecaps seen and the roar of the bay are the battle cries of the warriors and Chichi-Okobee when the storm god tries to flex his muscles against the bay? Is this the reason why Sarasota never seems to have a direct hit from any tropical storm or hurricane? If nothing else, it is a beautiful tale of a beautiful place.

THE CORAL CASTLE

Homestead

*T*he Coral Castle is one of the most amazing structures ever built. It has been compared to wonders such as the great pyramids of Egypt and Stonehenge. Some would even call it a miraculous creation because it was quarried, fashioned and built by one man. Edward Leedskalnin was a Latvian immigrant who stood only five feet tall and weighed only one hundred pounds. How could such a small man craft a modern castle in the blistering heat of Miami-Dade County during the time of the Model T?

The building material that Edward used is quite remarkable. The Coral Castle was built from huge blocks of coral rock, many of which weighed as much as thirty tons. He was able to move these blocks and set them into place without any assistance and without the use of any modern machinery. When asked, Leedskalnin simply said, "If you understood the ways that they built the pyramids, you could do it yourself easily."

The castle itself is a marvel to behold. The walls that surround it are about eight feet tall and are composed of blocks that each weigh several tons. A nine-ton swinging gate stands at the back of the castle. For years, it would swing weightlessly in the breeze, until 1992, when the violently strong Hurricane Andrew finally managed to dislodge it. The rough estimate is that over one thousand tons of coral rock were used to construct the walls and towers of the castle. An additional one hundred tons of coral were carved into the furniture and artistic objects that Ed used to decorate his palace. Some of the stones that make up the castle are twice the weight of

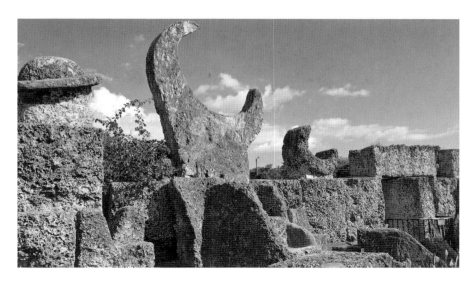

Some of the carvings atop the obelisks that make up one wall in the Coral Castle, as carved by Edward Leedskalnin, with his love for astronomy very prominently on display.

the largest blocks in the Great Pyramid at Giza. One obelisk that he raised weighs over twenty-eight tons.

Because he worked alone, it took Leedskalnin nearly twenty years to build the home that he called "Rock Gate Park" in Florida City. The legend, as it is told by the current caretakers of the castle, states that when Ed was sixteen years old, he was jilted at the altar by his true love because he hadn't made anything of himself. Then he came to Florida City after being diagnosed with tuberculosis. He was told that the area would be good for his health. He began the construction of his castle of coral in 1920.

In 1936, a subdivision was planned near his home and threatened his privacy, so he moved his entire castle, with its tons of coral, to its current home in Homestead, Florida. This was a distance of over ten miles. Edward did it with only the assistance of one friend with a truck. He completed his castle just a few years later, and it still stands today.

The legends of how he managed these impossible feats of engineering remain a mystery because no one ever saw him do any of it. Ed often did his work by lantern light during the night. There have been no witnesses who have been able to explain how such a small and frail man was able to move such large blocks of coral rock. Even the moving of the entire structure occurred at night with him using a borrowed truck. No one ever witnessed how he loaded or unloaded the vehicle.

Of course, there are numerous stories about how he moved the blocks. One story is that the neighbors allegedly saw him place his hands on the stones and sing in a strange language. This somehow allowed him to lift the stone with a simple touch, as if by levitation. Another theory is he used giant magnets and gravity manipulation. Leedskalnin was fond of these theories, and he allowed them to spread. He took the secret of his techniques to his grave in 1951.

Edward opened his castle to visitors in 1940. For only ten cents a visit, he would take visitors on a tour of his castle. First, guests would enter through the three-ton gate that sat perfectly balanced atop the axle of a Model T. Even the smallest child would have been able to open this seemingly weightless gate with ease. As guests made their way around the castle, he would explain to them how each piece worked and what it represented. The inside of the castle houses many of Ed's unique creations, including a giant stone table that resembles the state of Florida. It even comes complete with a water basin to catch rain exactly where Lake Okeechobee would be.

Leedskalnin was truly an incredible sculptor. He fashioned himself a well and a forge. He even chiseled a bath for himself into the coral. He also constructed a sundial and aligned a monument to coincide with the rising of the North Star. There are also functioning rocking chairs that he carved out of pure coral stone. In the second story of the main tower, one can still find Ed's hammock in his minimalist bedroom with a beautiful view overlooking the courtyard of his majestic palace.

Though he worked alone, Edward was not a hermit. He had several friends. One friend, Orval Irwin, wrote the book *Mr. Can't Is Dead! The Story of the Coral Castle*. In it, he explains how the castle was built using pulleys and leverage. The book contains drawings, rare photographs and even schematics made by Leedskalnin. This book claims that no alien technology or mysticism played any part in the building of the castle, just good ol' hard work. He says that if Ed did have some sort of supernatural powers, then he probably could have built the place in a few weeks rather than twenty years.

Although it is fun to think that the old and lovelorn Latvian who spent his life constructing the Coral Castle did so with some arcane knowledge, lost technology or superhuman powers, it's reassuring to know that he did it just like you or I would have: through patience, determination and hard work.

In 1951, Edward grew ill. He posted a sign on the gate that read, "Going to Hospital." Then he boarded a bus to Jackson Miami Hospital. It is unclear whether he suffered a stroke there, before or after, but he died less than a month later from kidney failure. Oddly, the reports showed no sign

The entrance to the Coral Castle, with Edward Leedskalnin's carved admission sign complete with a slot for deposited coins made out of scavenged automobile parts.

of tuberculosis. Either he had been misdiagnosed or he had somehow cured himself of the terrible disease.

After his death, Ed's castle sat idle, and people claimed many of his tools and belongings, until the Levin family purchased it in 1952. They restored some of the grounds that had been damaged and turned it into a roadside attraction. It was sold to a private company in 1981 and listed in the National Register of Historic Places in 1984. To this day, the Coral Castle is a truly wondrous place to visit and behold—although now the cost has gone up some from ten cents.

UFOs AND USOs

Gulf Breeze

T he town of Gulf Breeze, Florida, sits near the northwestern corner of the state, right on the Gulf of Mexico. It is located on the Fairpoint Peninsula and is a suburb of nearby Pensacola, the westernmost city in Florida. Many of the town's inhabitants work at the Pensacola Navy Base or nearby Eglin Air Force Base. Gulf Breeze is a well-known spot where tourists can visit sandy beaches or go out into the Gulf of Mexico to catch sharks or other sport fish. The white sandy beaches here are some of the most enjoyed in the world. It is also a popular destination for hunters searching for a glimpse of an unidentified flying object (UFO).

In 1987, Gulf Breeze became world famous when a series of UFO sightings was documented with spectacular photos by a man named Ed Walters. Over a period of about three weeks, Walters was able to capture some amazing photos of an alien craft. He reported himself being abducted and even sketched an impressive alien in a suit of armor that he claimed had observed him through a window. Not only did Ed Walters become suddenly famous; the sleepy suburb of Gulf Breeze did as well.

By 1990, the bulk of the excitement had died down as many skeptics and even some avid believers began to discredit Ed Walters. Several of his photos were proven to be hoaxes. Most proved to be double exposures, and a model was even found in his home after he moved that looked strikingly similar to the craft in his photos. One boy in town even came forward to say that he was an accomplice to the staging of the photos. Walters claims this is all disinformation designed to discredit him. The divided opinions on

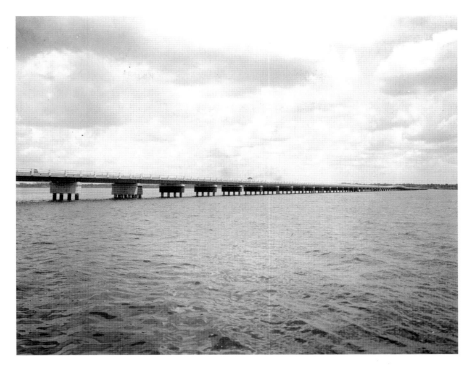

The Pensacola Bay Bridge in a photo from 1931 shortly before it opened, connecting Pensacola and Gulf Breeze. *Courtesy of University Archives and West Florida History Center, UWF Libraries, Pensacola.*

this case have called into question Ed Walters's case. Debating the validity of the dozens of reports by others of incidents involving UFOs in the area continues to this day.

The city is also the home of many USO (unidentified submerged object) sightings. These sightings are not usually separated from UFO sightings by those who study these phenomena because one usually becomes the other: either the object in question takes flight out of the water or it lands in the water and continues on undersea.

Gulf Breeze fishermen have been known to tell tales of strange glowing lights floating deep beneath them in the shape of a large triangle, with color-changing lights on the corners that pulse with an odd green glow. Some of these stories involve the large dark triangle rising up and coming out from under them. One fisherman told us that his depth finder, in the blink of an eye, went from four miles to shrieking a warning that he was in only twelve feet of water as the underwater craft rose up beneath him.

The large triangular USO becomes a UFO as it leaves the ocean silently. *Illustration by Kari Schultz, 2017.*

The one thing most of these stories have in common is that the craft comes up out of the water but displaces very little sea. No great wake or unusual waves occur as the craft breaches the surface and rises into the air. They have been described as moving at a slow speed, even hovering in place for periods of time. Then, quite suddenly, they zoom away at an incredible speed. All of this while making virtually no sound, only a slight hum.

While it is easy to dismiss these stories as mere fisherman's tales, the sheer volume of them does add some weight to their merit. USOs are hardly a new phenomenon, with tales going back as far back as Christopher Columbus. The crew of the *Santa Maria* is said to have seen a USO as they sailed to the New World.

While those who study UFOs (they call themselves ufologists) are quite familiar with the black triangle UFOs, particularly those around Gulf Breeze, most do not believe them to be of extraterrestrial origin. The most frequent sightings of these objects are near military bases, like the naval base at Pensacola. Is this perhaps some new stealth aircraft the government has yet to unveil? The name Project Aurora is linked to reported sightings of these type of craft in several leaked, but still heavily redacted, government documents.

Many theories also suggest bioluminescence from some of the larger creatures that inhabit the sea in the area. Unusually large sharks and whales, while uncommon in the area, are possible, and they do create some greenish glows when swimming in the deep. There are not, however, many reports of flying sharks or whales outside of the Syfy Channel's *Sharknado* movies.

Another theory is that these crafts belong to the lost civilization of Atlantis. Many postulate that it could be located just off the northwestern coast of Florida, deep in the Gulf of Mexico. Sadly, there is even less evidence to back up this theory than there is of the Roswell crash in New Mexico.

What we do know is that there have been a number of reported sightings of unusual things in Gulf Breeze. While visiting the area, you may see something in the water you can't explain. You might see something in the sky you can't explain. Either way, you will be in a lovely Florida town enjoying the amazing tropical climate on the beautiful Gulf of Mexico.

DOZIER SCHOOL FOR BOYS

Marianna

*M*any of our stories involve unusual events from history, including tragedies, legends and even murder. None of the stories compare to over a century of real-life horror that occurred in one place in Florida, a place that, until as recently as 2011, continued to provide constant stories of abuse, torture, rape and even child murder. The extent of these allegations is still only speculated upon. That place was the Florida Industrial School for Boys, and for 111 years, troubled boys were sent there for "re-education and reform." Many never returned.

The campus of the Florida reform school originally opened on New Year's Day 1900. This 1,400-acre facility was intended to house young delinquents convicted of serious crimes. It didn't take long for the list of crimes to expand and include minor infractions like truancy, running away from home and even "incorrigibleness." Most of the boys sent there were between the ages of thirteen and twenty-one, and the average stay was supposed to be between nine and eleven months. Many stayed much longer.

At first glance, the campus seemed idyllic for troubled boys sent here. A small zoo was built at one point on the property to educate the children. Boys were seen playing sports, including baseball and boxing, when visitors would come by. The students learned vocational trades as well. Gardening and farming skills were taught, as those sent here also helped maintain the grounds. A varied curriculum was taught in the school rooms. Boys sent here at first thought this might not be such a bad place after all.

Aerial view looking west over a portion of the campus at the Dozier School for Boys in Marianna, Florida, 19—. *State Archives of Florida, Florida Memory.*

The campus of the school was originally split into two sub-campuses, one for white children and one for black. The North Campus was for "colored" students and remained segregated until 1966. On the South Campus, a small cemetery began to take shape as the school's death toll began to rise. By the time of the school's closure, there were thirty-one grave markers and corresponding records of only twenty-four deaths. Other historical records, however, show that from 1900 to 1973, over one hundred students died there. Where their remains are buried is unknown.

For decades, the allegations of abuse and mistreatment of the juveniles incarcerated there fell upon deaf ears. As early as 1903, a report showed that many of the children were kept in leg irons. By 1910, the school had received complaints about overcrowding and terrible conditions for the students. In 1914, a terrible fire occurred in one of the dormitories, killing six inmates and two of the staff. These were among the first recorded deaths at the school.

The name of the school would change many times. In the wake of investigation into the 1914 fire and charges of neglect against the board of governors overseeing the school, a change of governorship of the school occurred. This led to the name change to the Florida Industrial School for Boys. In 1957, a second campus opened in nearby Okeechobee calling itself the Florida Industrial School for Boys, and the main campus was renamed the Arthur G. Dozier School for Boys in honor of one of the former superintendents of the school. It remained under this name until its closure in 2011.

In 1929, the school built an eleven-room concrete detention building containing two cells, one for white students and one for black students, which would house the more violent inmates. Students began to nickname the building the "White House," and its reputation for severe beatings and worse soon followed. Students lived in abject terror of being sent to the White House.

It wouldn't be until 1968 that corporal punishment was officially banned by the state, and by that time, the reputation of the White House was so ingrained in the culture of the school that survivors of

Entrance to the Arthur G. Dozier School in Marianna, Florida, not before 1967. *State Archives of Florida, Florida Memory.*

this period still shudder to describe details of the brutality of the guards, house fathers and even superintendents. There are even some allegations of a secret rape dungeon for very young boys under twelve to be sent and molested. It is told by students at the campus that school officials would turn on huge industrial fans to block out the noise of the beatings and screams so the other inmates on campus wouldn't hear the horror transpiring just yards away.

In 1968, Claude Kirk, then governor of Florida, visited the school to personally check the conditions of those incarcerated there, as the reports of abuse had continued to pile up. At this point, the school housed over 564 boys ages ten to sixteen, with some held for minor infractions like truancy or running away from home. When the governor discovered the overcrowding and terrible conditions in which the children were being kept, he was quoted as saying, "Somebody should have blown the whistle a long time ago." The White House was officially closed and was to be used for storage from then on.

In 1969, the school fell under the responsibility of the Division of Youth Services of the newly created Department of Health and Rehabilitative Services (HRS). The dark history of abuse and torture was supposed to be a thing of the past, but the allegations continued. An investigation conducted by the Florida Department of Law Enforcement concluded that none of the previous allegations could be properly substantiated because too much time had passed. They did not investigate current accusations at the time, as they were not warranted to do so.

As decades continued to go by, the allegations continued, and stories of former students started to make the newspapers in the '70s and '80s, spurring additional inquiries into the school's history. A surprise inspection by HRS in 1982 discovered boys being hogtied or kept in isolation for weeks at a time. By this point, the South Campus had closed, and the school housed 105 inmates ages thirteen to twenty-one. Many of the inmates reported that they had been handcuffed and hung from bars in their cells after being caught running away from the school. When asked about this practice, some officials said it was never for more than an hour and that it was "fairly routine."

In 2009, the school once again failed an inspection. While numerous problems were cited, one was that the school still failed to investigate mistreatment claims by inmates. At this point, the school still housed over one hundred inmates, most of whom were there for committing rape or lewd acts on other children. One state representative said that the culture

of abuse at the school was so long ingrained that he felt there would never be an end. Finally, after over one hundred years of stories of neglect, abuse, rape and murder, the school closed for good in 2011, not because of neglect or the abuse allegations but due to budgetary reasons. The children were sent to other facilities throughout the state.

An organization called the White House Boys, made up of former inmates, was formed as a place to air stories of the past. The support group has grown into a political movement to bring light to what they state are over one hundred years of state-sponsored child abuse. In 2008, before the school's closing, they managed to have a memorial plaque placed outside the White House to mark the dark history of that particular building and the school around it.

The graveyard at the school (referred to as "Boot Hill") contains thirty-one markers. Due to the consistent underreporting, most estimated at least fifty other students to be buried at the school or nearby in unmarked

An interior view of the hospital at the Dozier School for Boys in Marianna, between 1940 and 1959. *State Archives of Florida, Florida Memory*.

graves. Some students told of a second graveyard on the North Campus for black students, but there were no records of any such location.

In 2012, Erin Kimmerle, a forensic anthropologist from the University of South Florida, was allowed to examine the site to identify the remains of a long-missing student. She was originally only allowed to investigate the area of the known graveyard and began her search. She discovered nearly fifty-five graves while the site bore only thirty-one markers. She knew there was more to this story and the White House Boys may have been telling more truth than they were originally given credit for.

Since the state intended to sell the school grounds, Dr. Kimmerle was pressed for time, and by December, she had released her initial report about the fifty-five graves and the likelihood of another graveyard on the grounds. While the nearby town of Marianna held protests and tried to defend the school's reputation, the overwhelming evidence quickly shut down these defensive actions. In August 2013, Governor Rick Scott issued a permit allowing anthropologists and archaeologists from the University of South Florida to excavate and examine the remains of any and all boys buried at the Dozier site.

Using ground-penetrating radar and being guided by former staff and surviving inmates, the exhumations began at the school. While most institutions have very detailed records, Dozier had at best vague lists of names and causes of death, making locating bodies difficult. Some records simply stated "no longer here" or "assumed escaped." Some of these records may be the unidentified remains. In all, there are estimated to be over one hundred bodies, with a second suspected cemetery still undiscovered. Many of the graves contained multiple bodies within. Some of these graves had few remains with missing pieces. Attempts to identify the bodies are still continuing and made difficult by the lack of appropriate records. Many of the boys here were orphans with no family, so DNA matching is nearly impossible.

The horror stories of abuse told by the White House Boys on their website are enough to give you nightmares for months. Stories are reported by survivors of being taken out of bed at 1:00 a.m. and tied to an army cot in the White House. Reported abuses include being beaten by the infamous three-foot whip called "Black Beauty." You could hear it brush the walls and ceiling before landing on your back or behind. Inmates report blacking out during the beatings and only learning how many times they were beaten by other inmates in neighboring cells counting the lashes after somehow winding up in the overcrowded school hospital.

Some stories exist of sexual abuse in "the Dungeon," an inner room in the White House, by unknown individuals or even in the overcrowded dorms by fellow depraved inmates.

Another odd turn in this story occurred in 2014, when the body of one boy who was reported to have died while escaping in 1925 was exhumed. His reported cause of death was that he'd been killed by a train on a bridge while attempting to escape the school less than a month after arriving. His death was never reported by the officials of the school in any of their records. His casket was sent to his family in Pennsylvania by the school. They buried him with the rest of their family. As the recent probes into the school's dark history made the news, the family requested the remains to be examined.

When the casket was exhumed by more students from the University of South Florida, they came across something very unusual: there were no remains inside the coffin. The casket was simply filled with wood. There were no remains at all. It is theorized that this is yet another piece of decades of deceit from the Dozier School. With so many of the boys having no family, many were simply not missed. No one knows how many more cases like these remain.

At this time, only four of the unknown bodies in the cemetery have been identified. The reinterment of the unidentified remains is something of an odd situation in and of itself. The White House Boys are adamant that the remains should be reinterred far from the old Dozier School. They do not want them to be reinterred anywhere near the town of Marianna or even in the same county. Many of the survivors feel the town was complicit in the mistreatment of the inmates.

On a positive note, one of the spokesmen for the White House Boys stated recently in an interview with NPR that he had talked to prominent members of the town of Mariana, and they were willing to acknowledge their past, to apologize and to move on. Some of the White House Boys told him that they're now ready to do the same. On April 27, 2017, the Florida legislature finally issued a formal apology for the mistreatment of the boys at the Arthur G. Dozier School for Boys in Marianna on behalf of the state.

The second graveyard has never been confirmed or located. Due to many buyers being interested in trying to purchase the 1,400 acres that once housed the infamous school, time to locate the missing bodies may be running out. Most of the buildings are overgrown, and nature is reclaiming much of the abandoned property. It is very strictly off

limits to trespassers. Fences and security keep vandals and vagrants off the grounds.

Of course, there are numerous ghost stories of feeling the brush of young boys running by in the halls or seeing the shade of a boy from a past time seeking his earthly remains on the grounds. There are reports of hearing screams and even the "tap, tap, crack" of the lash of Black Beauty. These stories, however, pale in comparison to the true horrors that transpired at the Dozier School for Boys.

ROBERT THE DOLL

Key West

Key West is only ninety miles from Cuba but one hundred miles from Miami. Including a marker that is the southernmost point in the continental United States reachable by civilians, Key West is a unique city full of history. When first visited by Ponce de Leon in 1521, it was once known as the Cayo Hueso, which means "bone cay" or reef of bones, most likely due to the large number of bones left on the island by its early inhabitants, who used it as a communal burial ground. It held particular interest for many, as it was the westernmost key with a reliable freshwater supply.

There are many ghost stories and legends about what some refer to as the Conch Republic; an interesting story about that name is for a future book. Key West is famous for the Hemingway House, the Tennessee Williams House and what some call the Winter White House, which has hosted several former presidents, including Truman, FDR and JFK. There is one house that is now a bed-and-breakfast with a unique history in a unique town. It is called the Artist House, and for years it had a very special resident.

In the late 1800s, a young boy moved to Key West with his family. The boy, named Robert Eugene Otto, was the son of a wealthy businessman named Thomas Otto. The family bought a mansion in booming Key West. The city was the largest and most prosperous in Florida at the time, with so much trade with Cuba and being at the heart of the Florida straits between the Atlantic and Gulf of Mexico. The family had several servants, and one particular Haitian woman was Robert's nanny.

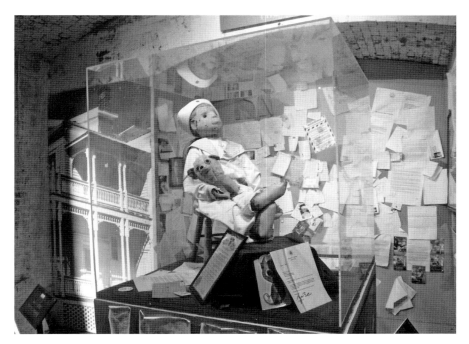

Robert the doll sits with his stuffed lion on display at the Fort East Martello Museum in Key West. *Author's photo, 2017, with the permission of Robert the doll.*

The legend goes that one day Mrs. Otto saw the nanny performing a ceremony of black magic and promptly dismissed her and forced her back to Haiti; however, before she left their service, she gave Robert a strange doll with a jester face that was about three feet tall, had buttons for eyes, was filled with Excelsior wool and had human hair, which many thought was Robert's. The doll was actually manufactured by the Steiff Company of Germany, and due to its unusual size of forty inches and his manner of dress, it is assumed that it was fashioned to look like its companion Robert.

Whether the doll was cursed by the voodoo-practicing dismissed nanny or just simply a family gift is of some debate even to this day. What we do know is that Robert named the doll Robert after himself. The child began to go by a truncated version of his middle name, Gene, so no one would confuse him and the doll. With the two now inseparable companions sharing clothing and getting tucked in together at night, all seemed innocent enough.

Odd things started occurring, with mutilated toys and objects flying around the house. Gene would be scolded, but the boy would insist, "Robert

did it!" Gene was often heard having conversations in his room with Robert. He would ask questions in his normal childlike voice, but a deep, gravelly voice, that of Robert the doll, would respond. There are stories that say everyone knew it was Gene using two voices, but some servants claimed they heard the voice coming directly from the doll.

The mischief grew more and more troublesome, and servants were fleeing in droves. As the Ottos began to have trouble finding replacements fast enough, they turned to their family for assistance. At the urging of some relatives, the parents finally locked Robert away in a box in the attic, and for a time things settled down. Occasionally, there would be unusual sounds from the attic, but many dismissed them as just the sounds of the old Victorian house in Florida weather. When giggling or shuffling feet were heard, they assumed it must simply be the wind carrying the sound of a neighbor.

When Thomas Otto died, he willed the estate to his son, who had now grown into quite the artist. Gene Otto had helped design the Fort East Martello Museum. He had a new wife and now was returning to live in his childhood home. He dreamed of turning the house into a museum itself and began renovations quickly. While refurbishing the attic, he found his long-lost companion, Robert. The two were together again, and they would never part again until death.

Despite his wife's displeasure, Gene took Robert everywhere; the doll even sat in a chair by the couple's bedside every night. Mrs. Otto began to despise Robert and demanded he be moved back to the attic. Gene only agreed to this if they turned the Turret Room at the top of the attic into Robert's bedroom and he could still go up to visit the doll while he painted.

Robert continued his reign of terror from his domain of the Turret Room for years. There were reports of him locking Mrs. Otto or visitors in the attic. Sometimes, fine porcelain or other valuables would be broken, and Robert would be found nearby, having escaped from his room. One guest of the Ottos' reportedly fled into the night after having been awoken by Robert giggling at the foot of his bed.

At some point, Mrs. Otto had enough. Some stories say she went insane; others say she left. We do know she died shortly after leaving the house, with Gene never realizing his dream of making the house into a museum. He did make a wax imprint of his hands at the house called *The Artist's Hands*. The house became known as the Artist House around the time of Gene's death in 1974. Robert was the sole inhabitant of the house for several years.

People passing by the old empty house would see the doll looking out the Turret Room window at them, but never from the same angle. There are

some stories saying the doll would be seen in lower room windows or even beckoning people to come to the house. The house did eventually regain tenants, who all had stories about Robert the doll and strange incidents. One plumber was so scared when the doll appeared behind him when he heard giggling that he refused to finish the job, and the owners were forced to find an out-of-town plumber to work on the piping.

Myrtle Reuter, who purchased the home in 1974, took Robert out of the Artist House for the first time since Gene's death in 1980 when she moved to a house on Von Phister Street. Robert did not take kindly to this move, and even more stories about him began. In 1994, Myrtle had tired of Robert's antics and donated the haunted doll to the Fort East Martello Museum that Gene Otto had helped design. Myrtle passed away just a few months later.

It didn't take long for Robert to begin to cause trouble at the museum. While not initially on display, there were still reports of the doll leaving his home in the archival storage area and winding up in all sorts of odd spots in the museum. Security cameras and other electronic devices would malfunction or fail suddenly. Motion sensors would be triggered at odd hours, and security would find Robert had moved again. The side effect of this was Robert's fame was growing again.

The museum staff finally agreed to put Robert the doll on display While cameras and other recording devices would malfunction around the doll quite frequently, one psychic suggested that as long as people were to ask Robert's permission for photos and not disrespect him, then Robert would not curse them or break their equipment. Robert continues to change positions in his case from time to time but seems to be happy on display for visitors. Letters began to arrive addressed to the doll asking for forgiveness for acting disrespectful or taking his picture without permission. Many letters are displayed behind the doll, and they are changed quite frequently, as so many pour in to this day.

Robert sits in his display…for the most part. One manager claims that after locking up and turning out all the lights one night, he came back the next morning to find all the lights on and Robert in a new location with sand on his feet. Robert has been out of his display a few times now when he made a trip up to Clearwater, Florida, in 2008 for a paranormal convention and another recent trip in 2017 to be on a TV show in Las Vegas featuring famous paranormal objects. These mark his only known trips outside Key West, all the while holding his stuffed lion companion.

So when you visit Key West, you can buy a Conch Republic shirt and visit the marker for the southernmost point in the United States (the real

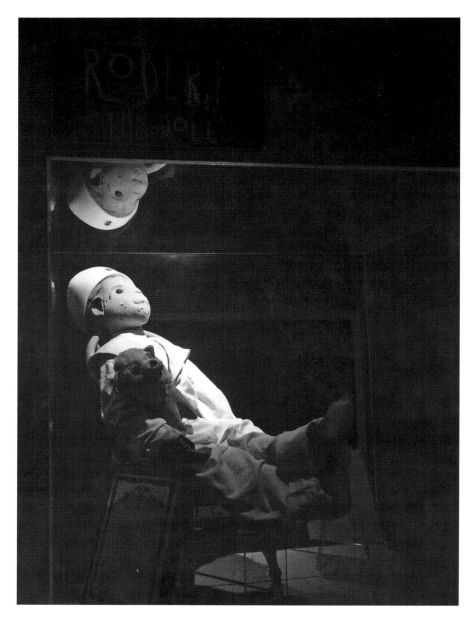

Robert the doll at night. *Author's photo, 2017, with the permission of Robert the doll.*

point is actually on a private island a little ways farther south). You can visit the homes of many great artists from American history and even take a ghostly tour that will tell you about the reef of bones or the many ghosts and legends of the amazing city of Key West. One tour will even take you into the Fort East Martello Museum after hours for some one-on-one time with Robert. Just make sure you ask his permission before you take a photo, and mind your manners and be polite to him. You seriously don't want to be on his bad side.

In Closing

W hile traveling the highways and dirt roads of this wonderful state collecting the pictures for this book, Kari and I gained even more stories. We had already whittled down our huge collection of stories to the list you just read. What we decided to present to you here really was the mere tip of the iceberg of *Eerie Florida*.

We followed the paths taken by many before us and listened to many ghost tours, fishermen's tales, cryptozoologists and historians' lectures. We read tons of books, many by our publisher, The History Press. We dug through archives at the St. Petersburg Museum of History, the Gulfport Historical Society and many others. Books at Park Place in St. Petersburg was so helpful in supplying us with hard-to-find titles for research and reference as needed.

By the end, as we organized all our notes, we simply had too much material for a single book. So if you enjoyed this book, visit us online at eerieflorida.com. There you can see even more photos and some videos we took at various places we've traveled. We plan to continue our journeys in search of further tales, and perhaps you can get a glimpse of the next book from us at *Eerie Florida*.

See you on the other side.

The author, the illustrator and an unidentified friend.

ABOUT THE AUTHOR
AND ILLUSTRATOR

*M*ark Muncy is the creator of Hellview Cemetery, a charity haunted house in Central Florida that was so infamous it was banned by the City of St. Petersburg. An author of horror and science fiction, he has spent over three decades collecting ghostly tales and reports of legendary beasts. This is his first work for The History Press. He lives in St. Petersburg, Florida, on the remains of an ancient midden with his fiancée, Kari Schultz. Occasionally, he is visited by his daughters when they remember he is still there.

*K*ari Schultz is a varied illustrator at Fox Dream Studio who enjoys fantasy and horror. She has been working on art as long as she can remember and reading folklore and horror almost as long. She has a short comic featured in *Uncanny Adventures: Duo #2* from 8th Wonder Press. This is also her first work for The History Press. She has a thing for foxes. She is being held captive in St. Petersburg, Florida, with a small party of fish, snails and plants until she can get more work published. She appreciates good cheese if you have any to spare.